SCRATCH MUSIC
Edited by Cornelius Cardew

1

SCRATCH MUSIC
Edited by Cornelius Cardew

Including Scratch Music by
Cornelius Cardew
Stella Cardew
Carole Finer
Lou Gare
Phil Gebbett
Bryn Harris
Christopher Hobbs
David Jackman
Diane Jackman
Christopher May
Tim Mitchell
John Nash
Michael Parsons
Tom Phillips
Howard Skempton
Catherine Williams

Also including '1001 Activities' by members of the Scratch
Orchestra, and musical compositions by David Ahern, Greg
Bright, Michael Chant and Roger Frampton.

The MIT Press
Cambridge, Massachusetts

First published 1972 by Latimer New Dimensions Limited

Introduction © Cornelius Cardew

The copyright of the pieces included in the Scratch Music Catalogue remains the property of the individual authors.

No part of this publication may be reproduced or transmitted in any form without permission in writing from the publishers.

First MIT Press paperback edition, 1974

Library of Congress Catalog card number: 73—7123
ISBN 0 262 53025 2 (paperback)

Printed in Great Britain

CONTENTS

I thank all the contributors for their help in preparing the Scratch Music spreads, also for helping with typing and editorial advice.

<div align="right">C.C.</div>

INTRODUCTION What is Scratch Music? Scratch Music is one sector of the repertoire of the Scratch Orchestra.

What is the Scratch Orchestra? The Scratch Orchestra was formed on the basis of a Draft Constitution *(see illustration)* that I wrote in May 1969. It was founded by Michael Parsons, Howard Skempton and myself. The first meeting on July 1st 1969, was a gathering of about 50 people — musicians, artists, scholars, clerks, students, etc — willing and eager to engage in experimental performance activities.

Scratch Music was one of several categories outlined in the Draft Constitution. Other categories were: Improvising, playing compositions written by ourselves or other present-day composers, playing the Popular Classics in ways vastly different from the way their composers composed them and their audiences loved them.

Scratch Music was halfway between composing and improvising. I saw it as a necessary curb on the combined free expression of fifty players, and as a training ground. At the meeting of July 1st some of us already had examples of Scratch Music to show to newcomers. I wanted members to spend the next two months or so (there was to be no second meeting until Sept 30th) composing Scratch Music and preparing for our first sound-making experiences as an orchestra.

Scratch Music never really caught on amongst the broad masses of the Scratch Orchestra, partly because I wasn't confident enough to put it over strongly (many people simply didn't understand what they were supposed to do) and partly because of inherent weaknesses in the whole idea of Scratch Music — its individualistic bias, 'doing your own thing' in a public entertainment context, and the resulting alienation.

From the first playing meeting of the Scratch, Scratch Music had a function. Scratch Members' punctuality was always lax, so to fill the time between the arrival of the first person and the (presumed) last, those who had Scratch Music played Scratch Music. Very beautiful it was on many occasions, with latecomers simply tuning in to the sound environment of the room and adding improvised music to the general texture of interacting Scratch Musics.

This mixed breed Scratch Music continued in use as long as meetings of that type continued in use. The form was: When I considered everyone was present I would clear my throat, the Scratch Music would gradually die away and the meeting would begin. I generally had several points to bring up: gig offers, rehearsal times, appeals for programme suggestions, appeals for volunteer work addressing letters, distributing posters, etc, etc. These meetings were always in batches, say 8 weekly meetings leading up to 4

A Scratch Orchestra: draft constitution

Cornelius Cardew

Definition: A Scratch Orchestra is a large number of enthusiasts pooling their resources (not primarily material resources) and assembling for action (music-making, performance, edification).

Note: The word music and its derivatives are here not understood to refer exclusively to sound and related phenomena (hearing, *etc*). What they do refer to is flexible and depends entirely on the members of the Scratch Orchestra.

The Scratch Orchestra intends to function in the public sphere, and this function will be expressed in the form of—for lack of a better word—concerts. In rotation (starting with the youngest) each member will have the option of designing a concert. If the option is taken up, all details of that concert are in the hands of that person or his delegates; if the option is waived the details of the concert will be determined by random methods, or by voting (a vote determines which of these two). The material of these concerts may be drawn, in part or wholly, from the basic repertory categories outlined below.

1 Scratch music

Each member of the orchestra provides himself with a notebook (or Scratchbook) in which he notates a number of accompaniments, performable continuously for indefinite periods. The number of accompaniments in each book should be equal to or greater than the current number of members of the orchestra. An accompaniment is defined as music that allows a solo (in the event of one occurring) to be appreciated as such. The notation may be accomplished using any means—verbal, graphic, musical, collage, *etc*—and should be regarded as a period of training: never notate more than one accompaniment in a day. If many ideas arise on one day they may all be incorporated in one accompaniment. The last accompaniment in the list has the status of a solo and if used should only be used as such. On the addition of further items, what was previously a solo is relegated to the status of an accompaniment, so that at any time each player has only one solo and that his most recent. The sole differentiation between a solo and an accompaniment is in the mode of playing.

The performance of this music can be entitled *Scratch Overture*, *Scratch Interlude* or *Scratch Finale* depending on its position in the concert.

2 Popular Classics

Only such works as are familiar to several members are eligible for this category. Particles of the selected works will be gathered in Appendix 1. A particle could be: a page of score, a page or more of the part for one instrument or voice, a page of an arrangement, a thematic analysis, a gramophone record, *etc*.

The technique of performance is as follows: a qualified member plays the given particle, while the remaining players join in as best they can, playing along, contributing whatever they can recall of the work in question, filling the gaps of memory with improvised variational material.

As is appropriate to the classics, avoid losing touch with the reading player (who may terminate the piece at his discretion), and strive to act concertedly rather than independently. These works should be programmed under their original titles.

3 Improvisation Rites

A selection of the rites in *Nature Study Notes* will be available in Appendix 2. Members should constantly bear in mind the possibility of contributing new rites. An improvisation rite is not a musical composition; it does not attempt to influence the music that will be played; at most it may establish a community of feeling, or a communal starting-point, through ritual. Any suggested rite will be given a trial run and thereafter left to look after itself. Successful rites may well take on aspects of folklore, acquire nicknames, *etc*.

Free improvisation may also be indulged in from time to time.

4 Compositions

Appendix 3 will contain a list of compositions performable by the orchestra. Any composition submitted by a member of the orchestra will be given a trial run in which all terms of the composition will be adhered to as closely as possible. Unless emphatically rejected, such compositions will probably remain as compositions in Appendix 3. If such a composition is repeatedly acclaimed it may qualify for inclusion in the Popular Classics, where it would be represented by a particle only, and adherence to the original terms of the composition would be waived.

5 Research Project

A fifth repertory category may be evolved through the Research Project, an activity obligatory for all members of the Scratch Orchestra, to ensure its cultural expansion.

The Research Project. The universe is regarded from the viewpoint of travel. This means that an infinite number of research vectors are regarded as hypothetically travellable. Travels may be undertaken in many dimensions, *eg* temporal, spatial, intellectual, spiritual, emotional. I imagine any vector will be found to impinge on all these dimensions at some point or other. For instance, if your research vector is the *Tiger*, you could be involved in time (since the tiger represents an evolving species), space (a trip to the zoo), intellect (the tiger's biology), spirit (the symbolic values acquired by the tiger) and emotion (your subjective relation to the animal).

The above is an intellectual structure, so for a start let's make the research vector a word or group of words rather than an object or an impression *etc*. A record of research is kept in the Scratchbook and this record may be made available to all.

From time to time a journey will be proposed (Journey to Mars, Journey to the Court of Wu Ti, Journey to the Unconscious, Journey to West Ham, *etc*). A discussion will suffice to provide a rough itinerary (*eg* embarkation at Cape Kennedy, type of vehicle to be used, number of hours in space, choice of a landing site, return to earth or not, *etc*).

Members whose vectors are relevant to this journey can pursue the relevance and consider the musical application of their research; members whose vectors are irrelevant (research on rocket fuels won't help with a journey to the Court of Wu Ti) can put themselves at the disposal of the others for the musical realization of their research.

A date can be fixed for the journey, which will take the form of a performance.

Conduct of research. Research should be through direct experience rather than academic; neglect no channels. The aim is: by direct contact, imagination, identification and study to get as close as possible to the object of your research. Avoid the mechanical accumulation of data; be constantly awake to the possibility of inventing new research techniques. The record in the Scratchbook should be a record of your activity rather than an accumulation of data. That means: the results of your research are in you, not in the book.

Reprinted from 'The Musical Times', June 1969

Example

Research vector	Research record
The Sun	29.vi. Looked up astronomical data in *EB* & made notes to the accpt of dustmotes (symbol of *EB*) and sunbeams
	1-28. viii. Holiday in the Bahamas to expose myself to the sun.
	29.vii. Saw 'the Sun' as a collection of 6 letters and wrote out the 720 combinations of them.
	1.viii. Got interested in Sun's m. or f. gender in different languages, and thence to historical personages regarded as the Sun (like Mao Tse-tung). Sought an astrological link between them.
Astrology	3.viii. Had my horoscope cast by Mme Jonesky of Gee's Court.
	etc

(note that several vectors can run together)
(the facing page should be left blank for notes on eventual musical realizations)

Spare time activity for orchestra members: each member should work on the construction of a unique mechanical, musical, electronic or other instrument.

APPENDICES

Appendix 1 *Popular Classics*
Particles from: Beethoven, *Pastoral Symphony*
Mozart, *Eine Kleine Nachtmusik*
Rachmaninov, *Second Piano Concerto*
J. S. Bach, *Sheep may safely graze*
Cage, *Piano Concert*
Brahms, *Requiem*
Schoenberg, *Pierrot Lunaire*
etc
(blank pages for additions)

Appendix 2 *Improvisation Rites from the book 'Nature Study Notes'* (two examples must suffice)
1 Initiation of the pulse
Continuation of the pulse
Deviation by means of accentuation, decoration, contradiction
HOWARD SKEMPTON

14 All seated loosely in a circle, each player shall write or draw on each of the ten fingernails of the player on his left.
No action or sound is to be made by a player after his fingernails have received this writing or drawing, other than music.
Closing rite: each player shall erase the marks from the fingernails of another player. Your participation in the music ceases when the marks have been erased from your fingernails.
(Groups of two or more late-comers may use the same rite to join in an improvisation that is already in progress.)
(blank pages for additions)
RICHARD REASON

Appendix 3 *List of compositions*
Lamonte Young, *Poem*
Von Biel, *World II*
Terry Riley, *in C*
Christopher Hobbs, *Voicepiece*
Stockhausen, *Aus den Sieben Tagen*
Wolff, *Play*
Cage, *Variations VI*
etc
(blank pages for additions)

Appendix 4 *Special Projects and supplementary material*
(blank pages)

At time of going to press, the orchestra has 60 members. More are welcome. A meeting to confirm draft constitution and initiate training should precede the summer recess. Projected inaugural concert: November 1969. Interested parties should write to Cornelius Cardew, 112 Elm Grove Road, London SW13.

concerts — and generally a few more arranged at short notice — in the last fortnight, so there was a strong short-term dynamism about the meetings. After half an hour or so of business — it seems now as if nothing I said was ever challenged, and our general ethic was 'no criticism before performance'; in fact challenges and criticisms used to rear their heads sometimes only after a delay of months, — after half an hour of business we would get down to work, distributing copies of pieces, rehearsing, trying out the ideas that people wanted to put in their concerts.

Did this all have to change? It changed. The internal contradictions in the Scratch got sharper and sharper until, possibly triggered by the civic and press response (we had a concert banned on grounds of obscenity and the press went to town on the scandal) to our Newcastle Civic Centre concert on June 21st 1971, I opened the doors to criticism and self-criticism. A collection of the resulting documents was circularised under the title 'Discontent'. The most radical critique came from Catherine Williams, who suggested the liquidation of the Scratch. (It is interesting that Williams' contribution to the present book, though much of it falls outside most definitions of Scratch Music, is the most progressive in that it deals with mass movements, with unanimity, something that the Scratch has definitely not yet arrived at.)

The Scratch was saved from liquidation by two communist members. At the August 23/24 discussions of the Discontent documents John Tilbury exposed the contradictions within the orchestra, and proposed the setting up of a Scratch Ideological Group. I and several others were glad to join this group, whose tasks were not only to investigate possibilities for political music-making but also to study revolutionary theory: Marx, Lenin, Mao Tsetung. Another aim was to build up an organisational structure in the Scratch that would make it a genuinely democratic orchestra and release it from the domination of my subtly autocratic, supposedly anti-authoritarian leadership.

It was in the context of this Ideological Group that I tried to reconstitute Scratch Music under the heading 'Scratch Music; first steps in composition' (see under 'Early Outlines and Later Notes'). In the light of that text I had hoped to end this introduction on the note "Scratch Music is dead; Long live Scratch Music". However, the text has not been circularised amongst the Scratch; other ideas are in the fore-front, and may these develop fruitfully. Meanwhile I am forced to the following conclusion about Scratch Music: Scratch Music fulfilled a particular need at a particular time, at a particular stage in the development of the Scratch Orchestra. Such a need may be felt by other groups passing through a similar stage either now or in the future, and some or all of the basic notions of Scratch Music may again be useful, but for now, as far as the Scratch Orchestra is concerned, Scratch Music is dead.

(Extract from the Draft Constitution of the Scratch Orchestra, June 1969)

Scratch Music
Each member of the orchestra provides himself with a notebook (or Scratch-book) in which he notates a number of accompaniments, performable continuously for indefinite periods. The number of accompaniments in each book should be equal to or greater than the current number of members of the orchestra. An accompaniment is defined as music that allows a solo (in the event of one occurring) to be appreciated as such. The notation may be accomplished using any means — verbal, graphic, musical, collage, *etc* — and should be regarded as a period of training: never notate more than one accompaniment in a day. If many ideas arise on one day they may all be incorporated in one accompaniment. The last accompaniment in the list has the status of a solo and if used should only be used as such. On the addition of further items, what was previously a solo is relegated to the status of an accompaniment so that at any time each player has only one solo and that his most recent. The sole differentiation between a solo and an accompaniment is in the mode of playing.

The performance of this music can be entitled *Scratch Overture*, *Scratch Interlude* or *Scratch Finale* depending on its position in the concert.

(Extract from the New Draft Constitution of the Scratch Orchestra, 1970)

Scratch Books

Your Scratchbook is your own personal, private document, and as such anything at all can go into it. However, the original idea of a Scratchbook was that it should contain Scratch Music at one end and Research at the other.

The aim of the Scratchbooks was to establish concern and continuity.

Scratch Music was proposed as a kind of basic training for participation in the Scratch Orchestra, the idea being that each person should write a number of pieces of Scratch Music equal to or greater than the number of people in the orchestra.

Scratch Music, recommended rate of composition, not more than one per day, is basically accompaniments. An accompaniment is defined as something that allows a solo, in the event of one occurring, to be appreciated as such. Each piece of Scratch Music should in theory be performable continuously (whether agonizingly or enjoyably depends on the type of person doing it and on the mood he is in) for indefinite periods of time.

For the notation of Scratch Music any medium may be used: visual, musical, verbal; the notations to be made in a Scratchbook which may be a plain notebook or any similar collection of blank units (eg peeled sticks, card index, . . .).

Ideally every piece of Scratch Music should be flexible enough to become a solo, if the player feels that way inclined (for instance, it may be played either sitting or standing, either muted or un-muted), When a number of people are playing together it is up to the judgementof the participants as to whether more than one can be soloing at the same time.

Scratch music — its composition — is thoughtful, reflective, regular, treasuring the transitory idea; it is also about privacy and self-sustenance.

Scratch Music — its performance — is about 'live and let live', peaceful cohabitation, contributing to society, meaningless and meaningful work, play, meditation, relaxation.

(10 6 69)
Ask members to make up songs. Words and melody — without accompaniment. These will then be taught to the whole orchestra and sung in unison, either with or without scratchmusic.

(late 1970)
Think about: Rites and Scratch Music are vessels that catch ideas that would in the normal course of events be thrown away and forgotten, sometimes

definitely rejected. So should they be discontinued? Does this depend only on their usefulness?

(23 5 71)
For reasons of linguistic felicity the name Scratch Music has sometimes been used to describe quite other types of music than are dealt with in this book. Eg music produced by the Scratch Orchestra that does not happen to fall under any other heading; or: performance to kill time by one or more individuals without verbal intercommunication relating to the performance. Such music might be thought of as 'unnotated Scratch Music', where it is known that notation is intrinsic to Scratch Music in its original definition.

In the event of a record being produced one side might be entitled 'Scratch Music' and the other 'Unnotated Scratch Music' (or perhaps 'False Scratch Music').

(Summer 1971)
BOOK OF SCRATCH MUSIC (much of the outline that follows has been rejected in the present book)
Contents of the book would scatter over a wide range of categories, for example: Counting / Cyclical processes in general / Cosmic / Scrutinising Nature / Translation processes / Doodling / Programming / Games / Exercises / Traffic / Social / Privacy / Poetic visions / Variable versus invariable / Building – destroying / Exhaustiveness – Kombinatorik / Display / Bells.

The items – probably about 500 – would be plaited into a continuous rope wending its way amongst these categories. Frequently jostling together except for those that have specific visual presence. These should have preferential treatment (?use of colour and special papers). Individual contributors would be identified by some aspect, eg. Jackman's items by their John Bull type and the fact that they always appear (say) in the NW corner of the page.

The ceaselessness of Scratch Music would be emphasised. Scratch Music is the basic music of the world, going on everywhere, all the time. Nothing that is not Scratch Music except regular Western musical compositions since CPE Bach.

(10 9 71)
Particular and General in Scratch Music. Somewhere between the two, the notion of everbody active continuously on a reasonably quiet scale. This watered down version became accepted and was played often at Scratch meetings and probably for the last time at Alexandra Palace on August 31st

1971. 'Watered down' because in a group of say thirty people, not all have written Scratch Music (this book only records 16 authors of Scratch Music). So is it to end there? What about the ideals of conscientiousness, regularity and collective respect that are implied in the conception of Scratch Music? (Bringing ideas from the country into the 'civilised' environment, etc).

Scratch Music is a method of uniting a group of people. Anybody can write and play it, it can be used in education, at all levels.

The superficially private and individualistic quality of Scratch Music must be seen in prespective. It fosters communal activity, it breaks down the barrier between private and group activity, between professional and amateur, — it is a means to sharing experience.

(6 10 71)
Method.
The illustration spreads of Scratch Music were made up as follows, using random numbers to answer three questions: 1, How many pieces of Scratch Music on a spread? 2, Which people are these pieces written by? 3, Which items of Scratch Music from these people's Scratchbooks? Each composer of Scratch Music is allotted a particular position on the spread, and the items selected by random means are positioned on the spread in accordance with this allotment (eg, Howard Skempton's Scratch Music always appears on the left page in the top left corner).

The way in which neighbouring items jostle one another and interact is improvised. Each spread can be seen as a possible performance configuration with the various items all taking place simultaneously. It should be borne in mind that although in graphic terms a particular item may be dominant in relation to others, in musical terms it may not do so. An item expressed simply as one or two words could be quite dominant in a musical situation, although graphically it appears insignificant.

Every effort has been made to be true to the appearance of the original pieces of Scratch Music. However, colour and size have had to be sacrificed. The illustration spreads have been reduced in size by a factor of 50%. This is linear measurement; the area of the original spreads is four times that of the printed spreads. Information about the colours (if any) of the originals can be obtained by looking up the individual items in the catalogue.

The random method of selection of items for each spread was chosen for its resemblance to the actual (or potential) situation in the Scratch Orchestra where each person comes to a playing session prepared to play a certain piece of Scratch Music without knowing what items the others will be playing. However, other grouping methods are also possible. For instance, collections could be made of all the items of Scratch Music

written on a certain day (a lot of the Scratch Music is dated). Or, collections could be made of a number of items of Scratch Music relating to a certain theme. Or, any other method.

Needless to way, no Scratch Music is copyright.

Although in the original terms of Scratch Music it would naturally occur that a composer would play only his own Scratch Music, that in all likelihood he would consider himself the only one capable of playing his own Scratch Music, the presentation of a book such as this represents a default from these terms. But I reckon that Scratch Music can only survive and develop through having its current rules continually broken and modified, and submitting to constant redefinition.

(7 10 71)
At different times I asked several people if they would like to write something linking Scratch Music and Activities. Michael Chant sent the following note:

I know no one who claims to understand what Cornelius Cardew means by "scratch music".

it may be — and that this book has reached an existence is a slight confirmation of this surmise — that he means it to be connected with experiments in notation.

but these examples of scratch music are mere phenomena: the noumenon of Scratch Music remains beyond the intellectual intuition of uncountably many individuals.

as for activities — as for activities I can only say that for me the transformation to music takes place when a certain philosophical cast is present in their direction.

this hesitant passage to the musical is manifested in a quickening, insensible, of the sense.

the common mystery that in action all the problems vanish may be why a scratch music and an activity are similar.

Michael Chant 1971

Extract from 'Composing for the Scratch' 13.1.72

3) Scratch Music — First steps in Composition.

A piece of Scratch Music is a composition in the first instance to be played by the composer, alongside others similarly engaged. This lays the foundation of practicality: there is no point in writing something that you are not capable of performing. In the second instance (we are working along these lines at Morley College now) Scratch Music can be exchanged, so that A's piece is given to B to play while A plays B's piece. This lays the foundation for comprehensibility: your idea must be written down in a way that can be understood and performed by someone else. Through playing Scratch Music with others you gain experience of different ideas interacting with each other. This lays the foundation for composing pieces for several people.

Regular turnover is an important aspect of Scratch Music. The pieces should be played soon after they are written, so that the practical experience feeds back into the composing activity. (This differs from the original concept, in which a large number of pieces would be written before any were performed).

The dynamic range of Scratch Music. Because before the formation of the Scratch our fear was that everyone would be drowned out unless precautions were taken, much early Scratch Music consisted of 'minimal' activities. In practise, the Scratch Orchestra does not make a lot of noise except in certain conditions, eg, when there are a lot of drums, or saxophones (or arguments) around. The new idea of Scratch Music is based on the idea that music *should* rise above the general (acoustic and other) level of the environment. So that dynamics is seen now as a question of balance. If the level is so low as to merge with the environment, the interaction with the other musicians is reduced. If it is so high as to dominate the environment then it has moved out of the sphere where it can be influenced by interaction from the other players.

The condition that it should be performable for indefinite periods of time is an important aspect of Scratch Music. This combats prodigal expenditure of energy (which would bring things to an early close). More important, it means that the composer has to visualise the development of his idea in time. A truism: over a long period of time, nothing remains the same. The dynamic control of changes in time is a big part of composition.

The development of imagination through the composition of Scratch Music. Not so much 'practical imagination' ie the lively development of the possibilities of a situation, but more 'theoretical imagination', ie the ability to imagine how an idea is going to work in practise, or simply the ability to imagine what it's going to sound like (cultivation of the famous 'inner ear').

SCRATCH MUSIC

Small explosions
Bangs & pops

FRUSTRATE ANTICIPATION

HANDS

Get to know your own hands, their texture,
consistency, capacity, their potential. Get to
know other people's hands, largely by means
of your own — in comparison with your own
Let them be wilty, kind, strong, capable,
avenging etc. ... together or apart.
Similar procedure for FEET, EARS, HEAD,
PARTS OF FACE, FACE, BACK, FRONT - of BODY
— and so on —

String Piece.

The score to be played is a string stretched from one
side of the room to the other.
Audience are one side, players the other.
To play, a person must cross from the audience side to
the playing side.
To join the audience a player must recross to the
audience side.
Players read the score from one side to the other.
Embellishments can be attached to the string, but if
an embellishment weighs down the string another
player can remove it or place a support to raise
the string to its correct level.

The string should be treated with due respect; if
it breaks or is cut, or comes undone then the
piece ends.

A

HAMM — from "END-GAME" by SAMUEL BECKETT.

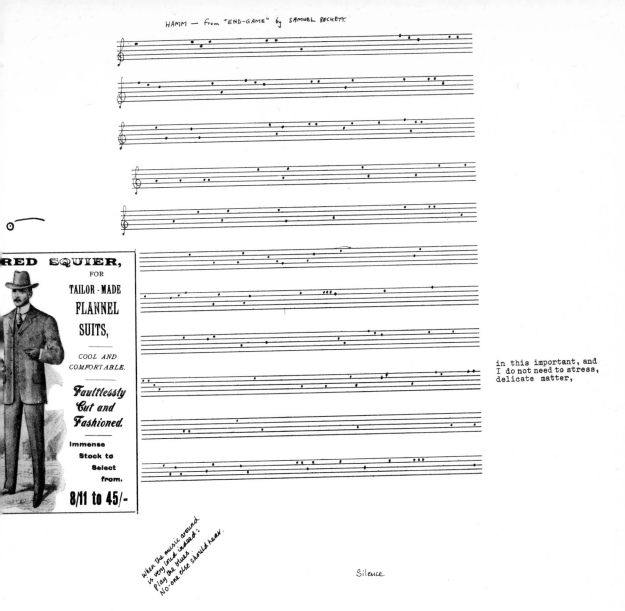

in this important, and
I do not need to stress,
delicate matter,

When the music around
is very loud indeed :
Play the blues.
No-one else should hear.

Silence

LOURED SMOKE

A

B

Lazy Scratch

Take a mat and a cushion

Arrange instruments within easy reach for playing when lying down

Play now and then, lying down

Go for a walk to see what others are doing now and then

Maybe play an instrument while walking

Chimes in an airstream

pulcritudinous
soSTENUTO
INTERMEZZO

I lay my saxophone on the curved table,
why should I trouble to play,
it is such hard work, and there
are'nt any breezes about today.

LIGHT A FIRE
THROW IN COPPER
FILINGS...GREEN
FIRE. WHEN THE
FILINGS HAVE ALL
GONE. ROAST POT
ATOES IN SILVER
FOIL. BOIL WATER
AND SERVE HOT DR

D

Make a sound.

Try to reproduce that sound as accurately as possible on another
 instrument (sound source).

Try to reproduce that sound as accurately as possible on another
 instrument (sound source).

Try to reproduce that sound as accurately as possible on another
 instrument (sound source).

Continue as above until;
 (i) you have produced sounds from every sound source available
 to you at that time,
 (ii) the sound has become as far removed from the initial
 sound as is possible,
 (iii) you become excessively bored.

[Do not use one sound source to make more than one sound.]

Some stones (2 or more)
about the size of a childs fist
or 2 or 3 sizes bigger

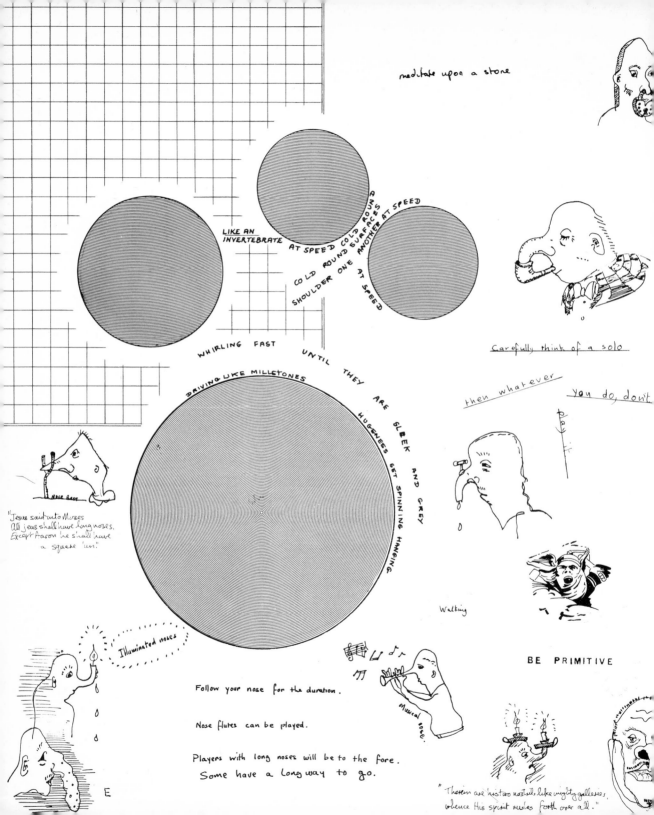

meditate upon a stone

LIKE AN
INVERTEBRATE

COLD ROUND COLD AROUND
SHOULDER ONE SURFACES AT SPEED
AT SPEED
AT SPEED

Carefully think of a solo

WHIRLING FAST UNTIL THEY ARE SLEEK AND GREY

DRIVING LIKE MILLETONES HUGENESS GET SPINNING HANGING

then whatever you do, don't

play it

NOSE BASS

"Jesus said unto Moses
All jews shall have long noses,
Except Aaron he shall have
a square 'un'."

Illuminated noses

Walking

BE PRIMITIVE

Follow your nose for the duration.

Nose flutes can be played.

Players with long noses will be to the fore.
Some have a long way to go.

Musical nose.

E

"There are his two nostrils like mighty galleries,
whence his spirit rushes forth over all."

a detail from The Waste Land (Tim Souster)

WHITE P. T. Machine

NELIUS CARDEW The Great Digest (Par. 6)

CKHAUSEN Abwärts, for ensemble (excerpt from Aus den sieben Tagen)
1st London performance

Later that evening in Joan's flat.
Pat is still overwrought.

CASTLE PARK, COLCHESTER. I X I. Series.

Crochet little coloured flowers to give to people

Master Musician

makes the sounds made by
musicians into music

Make a musical instrument.
Don't try for play it.

(by hearing them aright)
He makes the sounds around him
musical (by hearing them aright).
Occasionally he may add a
touch, a pizz , a belch
(very occasionally).

E

THE GREAT INVENTOR

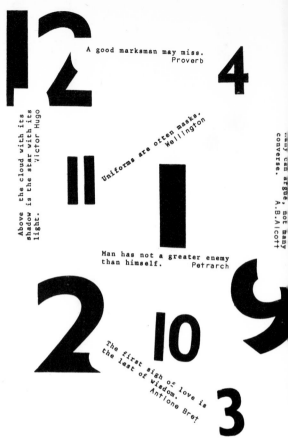

A good marksman may miss.
Proverb

Above the cloud with its
shadow is the star with its
light.
Victor Hugo

Uniforms are often masks.
Wellington

...any can argue, not many
converse.
A.B.Alcott

Man has not a greater enemy
than himself.
Petrarch

The first sigh of love is
the last of wisdom.
Antione Bret

F

Think of a person (a particular person — preferably someone you know);

Play that thought, and thus experience it more fully;

Think again;

Play again;

Think of another person, or the same person;

Continue as above;

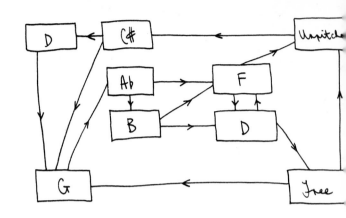

G

Silence

 – is it golden?

If it is → enjoy it.

If it is not → listen longer.

Virtuosity

Develop a skill

Legerdemain

eg. in the handling of a sledgehammer

		properly
Able		more or less
Unable	to do something	not at all

Play Lamento di Tristan
slowly and carefully,
softly, repeatedly.

H

EIGHTEEN

Tear up different sounding
paper into patterns, palm-
trees and confetti

Play one sound.

Repeat it.

Repeat it.

Continue repeating it until it bores you.

Repeat it.

Repeat it.

Continue repeating it.

Stop.

to your sound, each time you play it,
ess of the environment.]

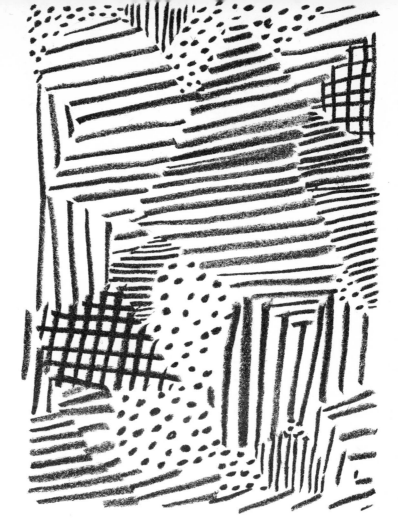

Rustling leaves
dry grasses
bamboos, reeds, rushes
Taffetta
silk
Tissue paper

Think of any simple tune,
such as a child's nursery
tune, and hum it quietly
backwards, taking as much
time as you need, & then some.

(Pause when you like)

I

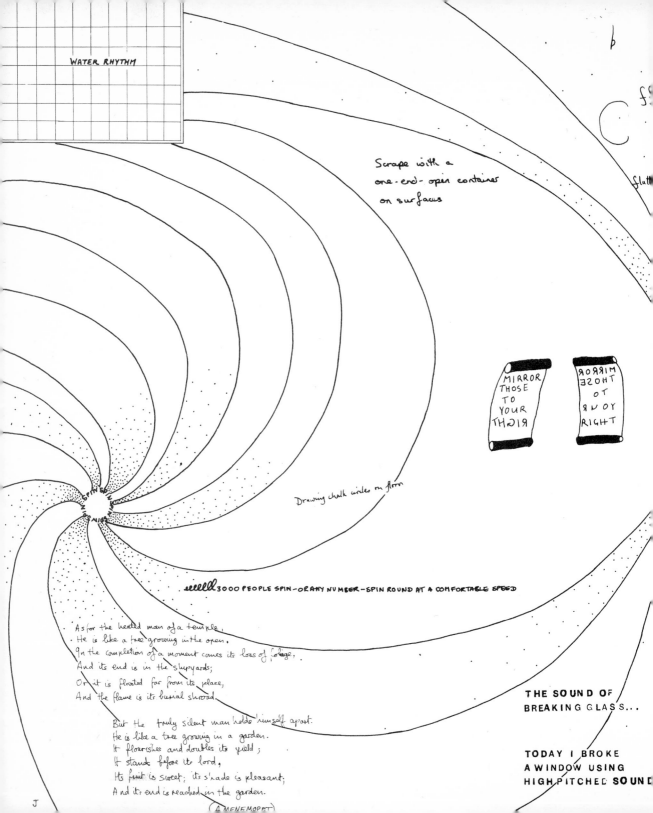

WATER RHYTHM

Scrape with a
one-end-open container
on surfaces

MIRROR
THOSE
TO
YOUR
RIGHT

MIRROR
THOSE
TO
YOUR
RIGHT

Drawing chalk circles on floor

3000 PEOPLE SPIN – OR ANY NUMBER – SPIN ROUND AT A COMFORTABLE SPEED

As for the heated man of a temple,
He is like a tree growing in the open.
In the completion of a moment comes its loss of foliage,
And its end is in the shipyards;
Or it is floated far from its place,
And the flame is its burial shroud.

But the truly silent man holds himself apart.
He is like a tree growing in a garden.
It flourishes and doubles its yield;
It stands before its lord,
Its fruit is sweet; its shade is pleasant;
And its end is reached in the garden.

(AMENEMOPET)

THE SOUND OF
BREAKING GLASS...

TODAY I BROKE
A WINDOW USING
HIGH PITCHED SOUND

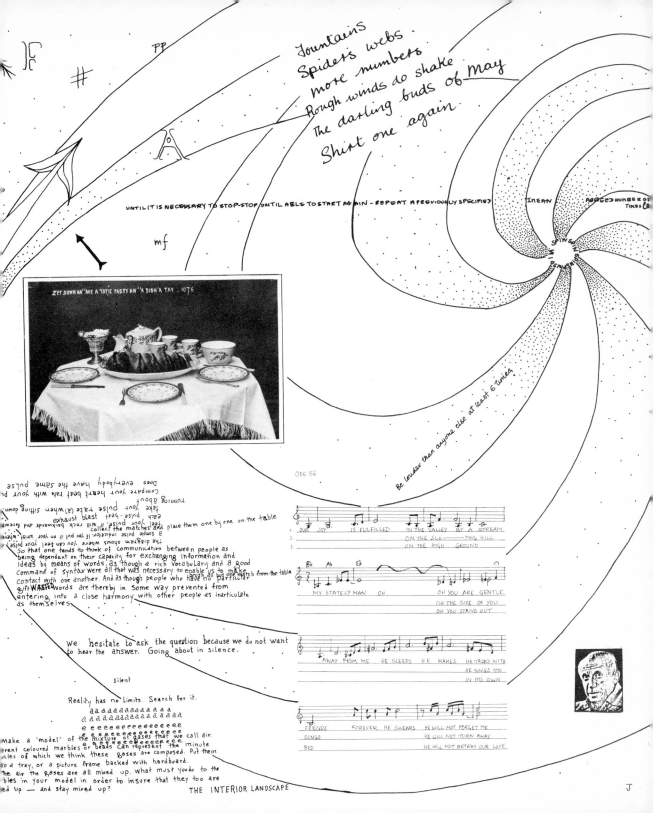

PP # A mf

Fountains
Spider's webs
more numbers
Rough winds do shake
The darling buds of May
Shut one again

UNTIL IT IS NECESSARY TO STOP-STOP UNTIL ABLE TO START AGAIN - REPEAT A PREVIOUSLY SPECIFIED

I MEAN RAGGED NUMBER OF TIMES (2)

SPIN CONTINUE

Be louder than anyone else at least 6 times

ZET DOWN AN "AVE A TATIE PASTY AN " "A DISH 'A TAY . 1076

Does everybody have the same pulse
Compare your heart beat rate with your pu...
running about.
Take your pulse rate (a) when sitting down.
each pulse - beat
exhaust blast it will rock backwards and forwards
collect the matches and place them one by one on the table
a simple pulse indicator if you put it on your wrist, when
The diagram shows where you can feel your pulse.

So that one tends to think of communication between people as
being dependant on their capacity for exchanging information and
ideas by means of words, as though a rich vocabulary and a good
command of syntax were all that was necessary to enable us to make
contact with one another. And as though people who have no particular
gift WASTED words are thereby in some way prevented from
entering into a close harmony with other people as inarticulate
as themselves.

ODE 56

1. OUR JOY IS FULFILLED IN THE VALLEY BY A STREAM
2. ON THE SLO————PING HILL
3. ON THE HIGH GROUND

Bb Ab Eb
MY STATELY MAN OH OH YOU ARE GENTLE
OH THE SIZE OF YOU
OH YOU STAND OUT

we hesitate to ask the question because we do not want
to hear the answer. Going about in silence.

AWAY FROM ME HE SLEEPS HE WAKES HE TALKS WITH
HE SINGS HIS
IN HIS OWN

Silent

Reality has no limits. Search for it.
aaaaaaaaaaaaaa
aaaaaaaaaaaaaa
e eeeeeeeeeeeeeee
eeeeeeeeeeeeeeee

Make a 'model' of the mixture of gases that we call air.
...rent coloured marbles or beads can represent the minute
...icles of which we think these gases are composed. Put them
...to a tray, or a picture frame backed with hardboard.
...he air the gases are all mixed up. What must you do to the
...bles in your model in order to insure that they too are
...ed up — and stay mixed up?

FRIENDS FOREVER HE SWEARS HE WILL NOT FORGET ME
SONGS HE WILL NOT TURN AWAY
BED HE WILL NOT BETRAY OUR LOVE

THE INTERIOR LANDSCAPE J

4 Saxophone
 with reed made from cigarette packet/playing card etc.
 Lowest sound possible, as soft as possible
 Repeat as many times as possible in each breath

4a using reed made from card, follow instructions for acc. 3

4b " " " " metal sheet, " " " "

K

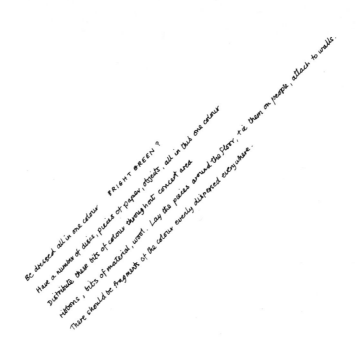

Be dressed all in one colour BRIGHT GREEN ?

Have a number of discs, pieces of paper, objects, all in this one colour

Distribute these bits of colour throughout concert area

ribbons, bits of material, wool. Lay the pieces around the floor, tie them on people, attach to walls.

There should be fragments of the colour evenly dispersed everywhere.

CENTIMETRES

10
9
8
7
6
5
4
3
2
1
0

|←———————— 150mm ————————→|

k

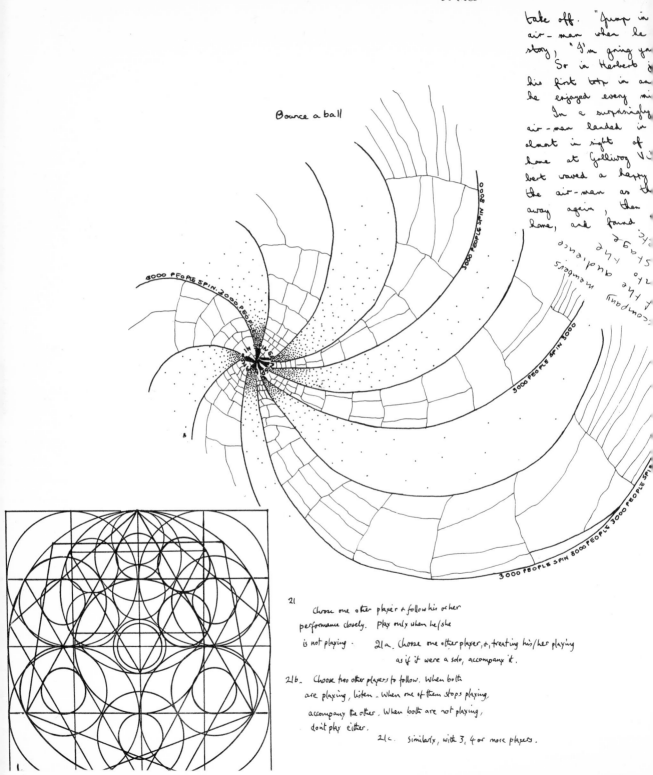

Bounce a ball

3000 PEOPLE SPIN 3000
3000 PEOPLE SPIN 3000 PEOPLE S
3000 PEOPLE SPIN 3000
3000 PEOPLE SPIN 3000 PEOPLE 3000 PEOPLE SPI
3000 PEOPLE SPIN 3000 PEOPLE 3000 PEOPLE SPI

accompany the audience etc.
the audience
company members
stage

take off. "Jump in
air - man when he
story, "I'm going y...
So in Herbert
his first trip in a...
he enjoyed every m...
In a surprisingly
air - man landed in
almost in sight of
home at Golliwog V...
but waved a happy
the air - man as th...
away again, then
home, and found

21 Choose one other player & follow his or her
performance closely. Play only when he/she
is not playing. 21a. Choose one other player, &, treating his/her playing
as if it were a solo, accompany it.

21b. Choose two other players to follow. When both
are playing, listen. When one of them stops playing,
accompany the other. When both are not playing,
don't play either.

21c. Similarly, with 3, 4 or more players.

England

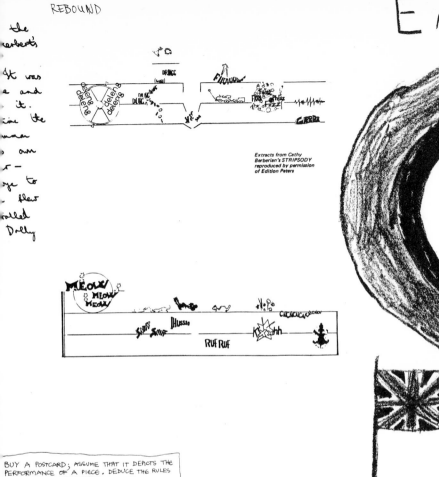

the
erbert's

It was
e and
it.
ine the
man
own
r —
ge to
lar
olled
Dolly

*Extracts from Cathy
Berberian's STRIPSODY
reproduced by permission
of Edition Peters*

BUY A POSTCARD; ASSUME THAT IT DEPICTS THE
PERFORMANCE OF A PIECE. DEDUCE THE RULES
OF THE PIECE; PERFORM IT.

FIREWORKS

M

M

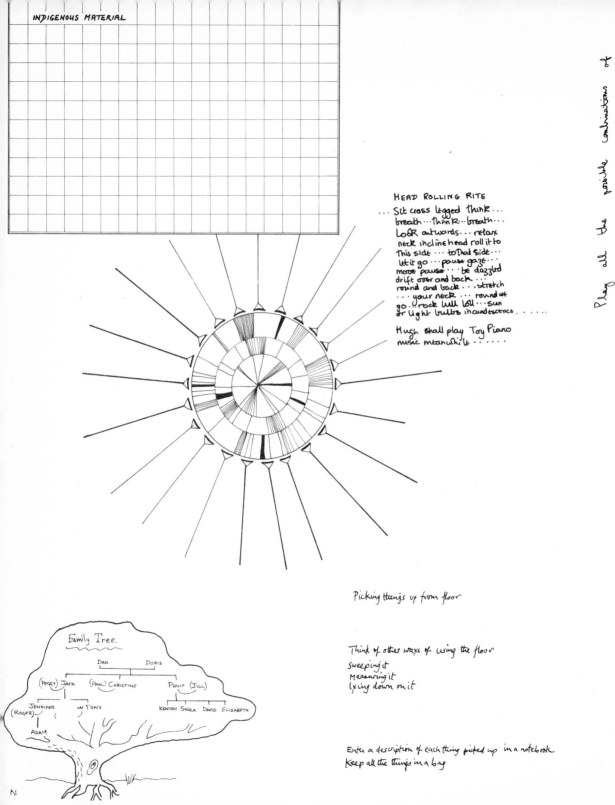

Play all the possible combinations of the recorder & fingering & ...

HEAD ROLLING RITE
... Sit cross legged think ...
breath ... think R ... breath ...
Look outwards ... relax
neck incline head roll it to
this side ... to that side ...
let it go ... pause gaze ...
move pause ... be dazzled
drift over and back ...
round and back ... stretch
... your neck ... round we
go ... rock till toll ... Sun
or light bulbs incandescence

Hugh shall play Toy Piano
music meanwhile

Picking things up from floor

Think of other ways of using the floor
sweeping it
measuring it
lying down on it

Enter a description of each thing picked up in a notebook
Keep all the things in a bag

Family Tree.

Dan — Doris

(Peggy) Jack — (Paul) Christine — Philip (Jill)

Jennifer (Roger) — Tony — Kenton Sheila David Elizabeth

Adam

Rolling sounds
Sounds made with any rolleable objects, rolled round trays,
saucepans, the floor etc.
Sounds to be smooth and continuous

Bees

ETC.

ictus

VERY SLOWLY
TURN WHATEVER
YOU ARE DOING
AT ANY TIME IN
ITS OPPOSITE

Ludwig WITTGENSTEIN:

"Ein Ausdruck hat nur im Strome des Lebens Bedeutung."

(An expression has meaning only in the stream of Life).

Thread strings of beads to give away

0

site-influenced music

One specific sound when people enter
another when people leave
further when people speak
 when people look at you

Do not make any other sounds.
If too many events occur at once make a note of the sounds and play them later
Set of rules on how to play can be worked out at the concert,
i.e. play something when people enter a specific area within the concert area
or play something when a recorder or other instrument is heard.

COPERNICUS
(3500)

p

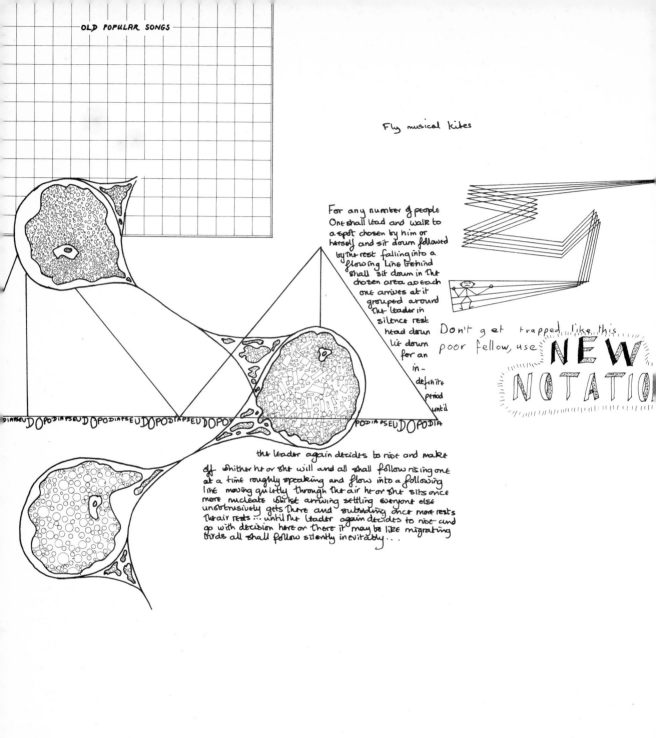

OLD POPULAR SONGS

Fly musical kites

For any number of people
One shall lead and walk to
a spot chosen by him or
herself and sit down followed
by the rest falling into a
flowing line behind
shall sit down in the
chosen area as each
one arrives at it
grouped around
the leader in
silence rest
head down
lie down
for an
in-
definite
period
until

Don't get trapped like this
poor fellow, use NEW NOTATIO

DIAPSEUDOPODIAPSEUDOPODIAPSEUDOPODIAPSEUDOPOD PODIA PSEUDOPODIA

the leader again decides to rise and make
off whither he or she will and all shall follow rising one
at a time roughly speaking and flow into a following
line moving quietly through the air he or she sits once
more nucleate whilst arriving settling everyone else
unobtrusively gets there and subsiding once more rests
their air rests ... until the leader again decides to rise and
go with decision here or there it may be like migrating
birds all shall follow silently inevitably ...

Q

white heavens with black stars.

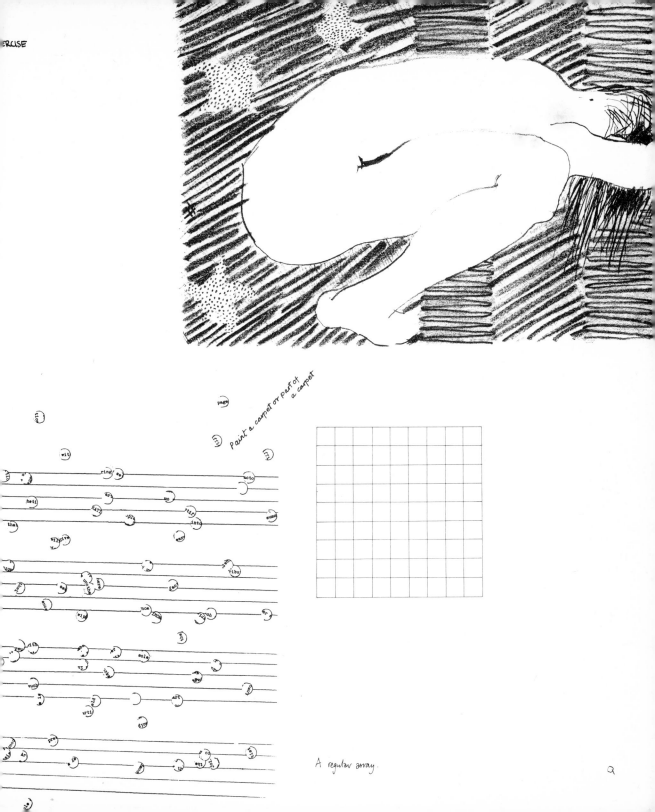

Paint a carpet or part of a carpet

A regular array.

Empty central space nec-
essary. Sit in a circle
surrounding the space.
Tend to have a collection
of usable materials/
instruments by you—one
person at a time
beginning with any
one, place one
object in the centre
—sit down
again.
Proceed to
build in
turn. Place
an object
or adjust the
pile/ it dis-
pleases you as
it is. One object
per trip. When
it seems every
one has had a turn

BUILD

DLIUB

singly, get up when someone else does. Two simultaneously BUILD.
Accumulate in numbers, until all BUILD at once. Fetch several objects at
once. UNBUILD (DLIUB) when the situation begins to get out of hand—or
source of objects runs out. Take back what you put on the pile
—your own possessions, or return other people's return into their places. Re-
constitute the circle—sit down when you think you have done enough. If you
don't want to BUILD — PLAY. If in the original circle make it clear
you intend to PLAY and not BUILD. Alternate if you wish. If there is an
audience suggest it should help to BUILD and UNBUILD also. At a certain
point BUILDING and UNBUILDING will interact as simultaneous forces. Rite
ends when the BUILT in space is once more empty.

Writing

(Too bulky to insert)

Description:

 Knotted rope ring

 of Twisted strands, colour coded
 plastic coatings, each with wire core
 which, when properly connected,
 houses a scene of wild electron
 activity.

 Some odd strands are separate,
 with stripe coding.
 Some strands in the rope are
 labelled: C7. C16. RLC1·9. C13

A B

'ACUTELY aware of our beings' limit-
ations and acknowledging the infinite mys-
tery of the a priori universe into which we
are born but nevertheless searching for a
conscious means of hopefully competent
participation by humanity in its own evol-
utionary trending while employing only
the unique advantages inhering exclusively
to the individual who takes and maintains
the economic initiative in the face of the
formidable physical capital and credit ad-
vantages of the massive corporations and
political states and deliberately avoiding
political ties and ... while endeavouring
by experiments ... orations to excite
'individuals' awa ... l realisation of
humanity's high ... ials I seek through
comprehensive ... ry design science
and its reductio ... cal practices to
reform the environment instead of trying
to reform men being intent thereby to acc-
omplish prototypes capabilities of doing
more with less whereby in turn the wealth
augmenting prospects of such design science
regenerations will induce their spontaneous
and economically successful industrial pro-
liferation by world around services' manage-
ments all of which chain reaction provoking
events will both permit and induce all hu-
manity to realise full lasting economic and
physical success plus enjoyment of all the
Earth without one individual interfering
with or being advantaged at the expense
of another.

A B

. (o)

R

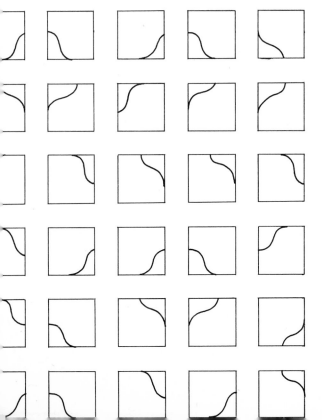

Tune a brook by moving
the stones in it.

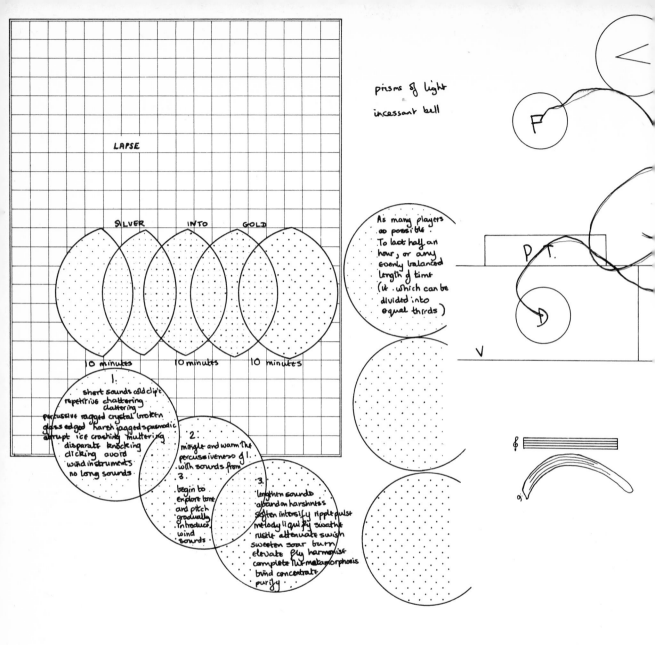

MAKE A DREAM OF PARADISE

Add one sound, thoughtfully,

to the environment.

Build a carpet
with coloured paper
or coloured ribbons
or coloured sticks

A person is to be considered as a
stimulus for sound production.
Consider his head. the further it is
from the ground the less complex the
overtone structure for instance. ie. if
he stood on his head — play the most
complicated overtone structure you could
manage. Consider his distance in relation
to yourself. The nearer he was the softer
you play for instance. A long way off
and you play loud.
Arms could indicate pitch.
speed of movement — attack.
visibility — Duration. (if he went behind
you or something which obstructed your
view of him — stop playing)

Moan quietly and sadly,
mouth open.

T

(Scratch) Orchestral piece with Gramophone

A gramophone record of an orchestral composition, known to have a scratch in it such as will cause infinite repetition of one groove, is taken and played. The (live) orchestra accompanies the record, repeating the music heard to the best of its ability. (What will come out is a sort of canon between the recorded and live performance.) The record should preferably not be a popular classic. The performers must play quietly to avoid losing touch with the record, which should not be played loudly.

When the record arrives at the repeating groove the performers should, after a few repetitions, be able to play in unison with the record. The general volume level would probably rise here. When a member loses touch with the record, he may go over to the gramophone and jerk the needle on. This action should be plainly visible to the other performers, who must immediately resume their low volume and follow the record as before. The performance ends a) (if the gramophone is automatic) when the gramophone switches itself off, b) (if the gramophone is manually controlled) at any time after the record has ended. The audible click which sometimes occurs as the needle moves around the innermost groove may be taken as part of the record, in which case a similar situation to the one described above may obtain.

The piece could be played by any performer(s), in which case the record should match as far as possible the instrument(s) or voice(s) used.

Take a closed cylinder
(empty pepsi-cola tin).
Bang it. Drop things
through the holes the
pepsi came out of.

Under a plane tree (audible) Wind. (audible) Thought.

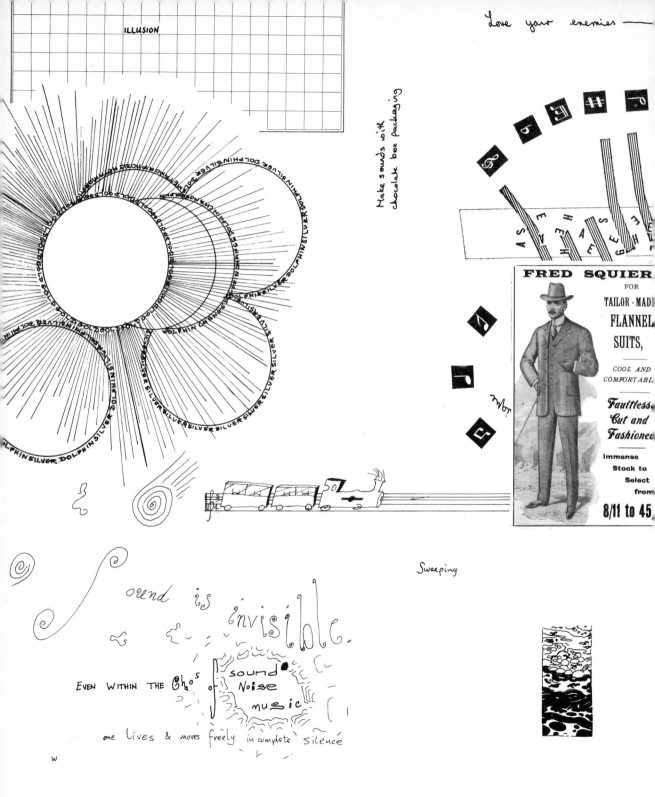

ILLUSION

Love your enemies —

Make sounds with chocolate box packaging

FRED SQUIER
FOR
TAILOR-MAD
FLANNEL
SUITS,
COOL AND
COMFORTABL
Faultless
Cut and
Fashioned
Immense
Stock to
Select
from
8/11 to 45

Sweeping

Sound is invisible.

EVEN WITHIN THE Chaos of sound
Noise
music

one lives & moves freely in complete silence

W

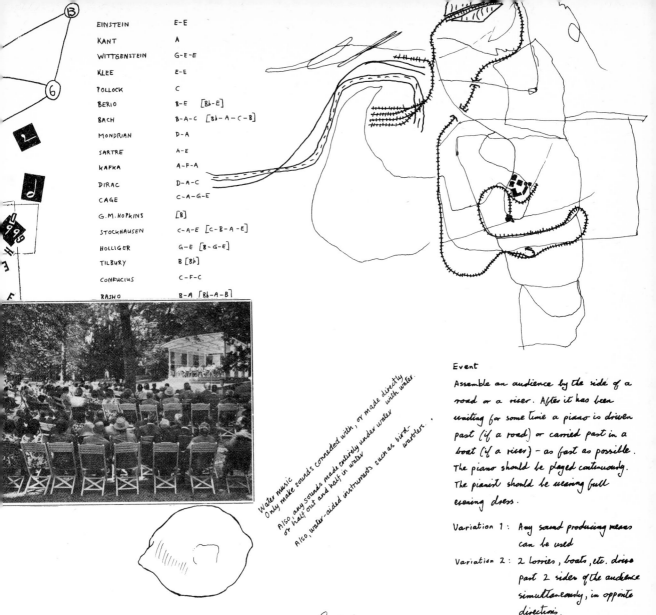

EINSTEIN E - E
KANT A
WITTGENSTEIN G - E - E
KLEE E - E
POLLOCK C
BERIO B - E [Bb - E]
BACH B - A - C [Bb - A - C - B]
MONDRIAN D - A
SARTRE A - E
KAFKA A - F - A
DIRAC D - A - C
CAGE C - A - G - E
G. M. HOPKINS [B]
STOCKHAUSEN C - A - E [C - B - A - E]
HOLLIGER G - E [B - G - E]
TILBURY B [Bb]
CONFUCIUS C - F - C
RASHO B - A [Bb - A - B]

Water music
Only make sounds connected with, or made directly with water.
Also any sounds made entirely under water
or half out and half in water
Also, water-aided instruments such as bird-warblers.

Event

Assemble an audience by the side of a
road or a river. After it has been
waiting for some time a piano is driven
past (if a road) or carried past in a
boat (if a river) — as fast as possible.
The piano should be played continuously.
The pianist should be wearing full
evening dress.

Variation 1: Any sound producing means
 can be used

Variation 2: 2 lorries, boats, etc. drive
 past 2 sides of the audience
 simultaneously, in opposite
 directions.

Conductor

Select a person nearby and
play him — his dress
 gestures
 physique
 expressions

You may advise him of what
you're going to do or not

¾ C ½ C
¼ D ½ D
C D

¼ E F
¾ E
¾ E ½ F
¼ F ½ F grey
E F

Play violin upside down.

w

WITH HASTE

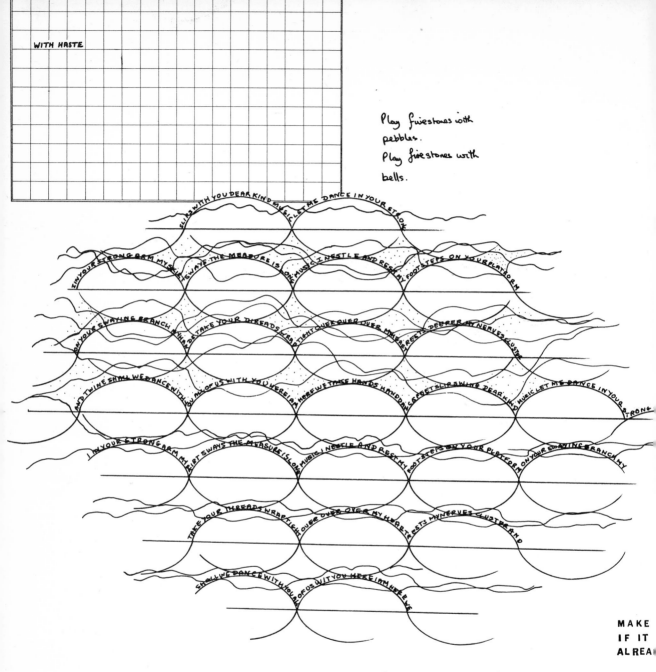

Play finestones with pebbles.
Play finestones with bells.

MAKE
IF IT
ALREA

Table Music

Make as many different sounds as possible with a
table :
e.g.- rhythmic drumming with hands & fingers
 rubbing with fingers (dry or wet)
 scraping, drawing across floor (as in Poem)
 scratching with fingernail

x

Walk music.
Movement music.
Stop – watch – listen.
Continue.

If inside play the sounds
from outside, if outside play
the sounds from inside.

The Beach, Saltdean. ET 4734

Instrument (and voice) practise
All forms of scales, arpeggios, chords, standard exercises,
practise - pieces from music teaching manuals.

IN.
NING
KE IT STOP

X

Using instruments or objects made wholly from wood.
make sounds.

The I Ching
46. Sheng/ Pushing Upward.

≡≡ K'UN The Receptive, Earth.
≡≡ SUN. The Gentle, Wind, Wood.

Within the earth, wood grows:
The image of pushing Upward.
Thus the superior man of devoted character
Heaps up small things,
In order to achieve something high and great.

Adapting itself to obstacles and bending around them, wood in the earth
grows upward without haste and without rest. This too the superior
man is devoted in character and never pauses in his progress.

57 Sun/ The Gentle (The Penetrating, Wind)

≡≡

Sun is one of the eight double trigrams. It is the eldest
daughter and symbolizes wind or wood; it has for its attribute gentleness,
which nonetheless penetrates like the wind or like growing wood
with its roots.

Rope

Knots: Round turn x 2 half hitches:

under, over + through x 2

Bowline:

Clove hitch:

then put right hand bop on top of left hand loop

Y

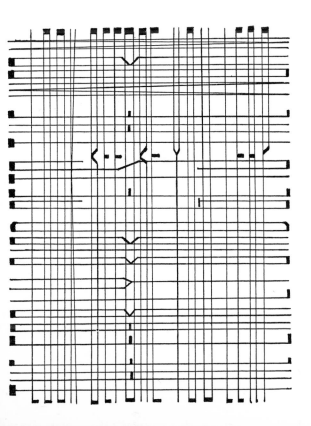

climb up

survey the land

descend

survey the heavens

Y

FRAGMENT

It is like a big tree, a little bird comes and sits in the tree and sings, it does'nt make any difference to the tree. It is a lovely day.

Key to Illustration Spreads

A — HS19, CM26, DiJ12, PG14, CW6, BH16, TP7, CH29, CF16, LG7, DaJ61, CC17

B — SC15

C — CM18, CF11

D — DiJ13, PG17, BH4, LG1, DaJ45, TM38

E — HS44, DiJ14, PG15, BH1, CW4, TP8, CF15, JN19, LG11, MP8, DaJ11, TM14, CC67, CH18

F — HS28, CM22, PG6

G — CM1, PG18, DaJ15, TM15, CC52, JN

H —

I — HS18, DiJ11, PG16, SC28, BH2, CF2, JN1

J — HS23, DiJ1, PG8, SC33, CW1, BH9, MP3, TP4, CF19, TM2, CC70, LG5, DaJ58, JN36

K — CF17, TP32, CH, MP2

L — DiJ17, CM24, PG10, SC18, CW2, BH5, TP2, LG8, MP10

M — PG7, DaJ60

N — HS32, CM4, CW7, CF3, LG4, MP4, CC40

O — CM23, PG13, SC23, BH25, CF18, CH, DaJ26

P — SC31, CW8, CF6, TM1

Q — HS5, DiJ7, CM25, SC19, BH6, CW3, CF12, LG9, TM26, CC7

R — CW10, MP7, CC12, JN13

S — BH11, DaJ12, TM21, JN

T — HS16, DiJ15, CM11, PG19, CW5, BH21, CF7, MP16, DaJ13, TM7, JN2

U — CM19, CH11

V — DiJ6, CC16

W — HS24, DiJ10, CM12, PG9, SC5, CW9, TP31, CF1, CH, BH15, LG10, MP17, DaJ68, TM12, CC55, JN

X — HS22, DiJ8, PG11, SC26, CW11, BH10, TP11, CH19, CF4, MP12, DaJ47

Y — LG2, MP14, TM32, CC39

Z — CM8, LG3

The catalogue is arranged in alphabetical order of composers. It is not a complete catalogue of Scratch Music. Some composers of Scratch Music have drifted away from the Scratch Orchestra and so their Scratch Books have not been available. Others have contributed only a selection of their work.

The descriptions given are by no means exhaustive.

'**Content**' means the verbal or numerical content of the piece of Scratch Music.

Where it seemed relevant, oblique strokes have been used to indicate line breaks.

The composers contributing are:

Cornelius and Stella Cardew, Carole Finer, Lou Gare, Phil Gebbett, Bryn Harris, Christopher Hobbs, David and Diane Jackman, Christopher May, Tim Mitchell, John Nash, Michael Parsons, Tom Phillips, Howard Skempton, Catherine Williams.

Cornelius Cardew

CC1 29.5.69 **Content** 1. Soft (A) ball bouncing (1). 2. Hard (B) ball catching (2). 3. Spiked (C) ball rolling (3). (Also: A2, A3, B1, B3, C1, C2). Play ball

CC2 30.5.69 Three thick horizontal ink lines, the first wobbly, the second straight, the third ruled, numbered (1) (2) (3). Description underneath each line in ink (bracketed) and pencil. Over the whole a light pink offprint of CC3. CC2 is separated from CC3 by a sheet of proofing paper. **Content** (1) (Overt tremble) tremble. (2) (Minimised tremble) tendency to tremble. (3) (Ruled line) no tendency to tremble.

CC3 6.6.69 24½ pink drops on art paper. The drops have pale centres where paint has offprinted onto CC2. They are randomly placed. Down the right side a strip of sellotape. **Content** a constellation.

CC4 7.6.69 The reverse of CC3 (Faint circular deformations of the paper).

CC5 3.6.69 A paint rag stretched between 2 pages with rectangles cut out of the centre. **Content** a) interweaving. Over under over under. . .

CC6 4.6.69 Two staves of music notation. Inspiration: (Ray Charles)

CC7 9.6.69 A pencil grid 9 cms x 9 cms with lines drawn every cm. **Content** A regular array.

CC8 10.6.69 Music notations showing unitary, binary, ternary and 4's. **Content** Counting systems (when 2 or more sounds are written vertically over one another only the bottom one need be played. The others are ad lib.)

CC9 11.6.69 Inspiration: (from Kagel) **Content** Pretend to play. Pretend not to play. (The play on appearances).

CC10 12.6.69 A stave of music notation. Inspiration: Based on something by Zappa. **Content** Wander (modulate) through the water-meadows of cadential harmony.

CC11 13.6.69 Pencil drawing of an electric cooking ring with frying pan and lid. Inspiration: (David Tudor and Peter Klein). **Content** Delicious smell. Roasting mustard seeds in a dry pan / coffee beans / hay (in case of having to feed a piano) / etc. / pop-corn /

CC12 16.6.69 **Content** (Too bulky to insert). Description: Knotted rope ring of twisted strands, colour coded plastic coatings, each with wire core,which, when properly connected, houses a scene of wild electron activity. Some odd strands are separate, with stripe coding. Some strands in the rope are labelled: C7, C16. RLC 1.9, C13

CC13 17.6.69 Irregular shape of squared paper glued down. Markings and numbers in blue biro, some squares filled in with pink and green crayon. Lavish glue and adhering proofing paper. A sheet of proofing paper is inserted between this and CC14. **Content** Play a game with dice and counters.

CC14 18.6.69 23¾ and ¼ pink drops on art paper as in CC3. The surface of the paper is damaged in places. A small square has been cut out to show part of the drawing of CC15 beneath.

CC15 19.6.69 Ink drawing of a dripping tap with integrated lettering. The page has been folded down the middle. Inspiration: (George Brecht). **Content** Drip Music.

CC16 20.6.69 Glued on: A plane tree leaf pointing downwards, maybe 2 cms across. **Content** Under a plane tree. (audible) Wind. (audible Thought.

CC17 24.6.69 **Content** Silence

CC18 A sheet of tracing paper inserted between CC17 and CC19. Some tiny spots of red fluorescent paint, but mainly it gives muted version of CC19.

CC19 26.6.69 A rectangle of irregularly applied red fluorescent paint. **Content** (electric).

CC20 27.6.69 An ink drawing on tracing paper of a pre-Han Chinese bronze T'ing vessel mounted with sellotape in a cutout rectangle. The drawing is in reverse. **Content** Ting.

CC21 4.7.69 **Content** One thing at a time.

CC22 6.7.69 **Content** Swing a transistor radio at a speed adequate to produce frequency modulation (other factors being equal).

CC23 12.7.69 **Content** Turning away. Turning over (eg in a confined space — like a tent). Turning up.

CC24 14.7.69 Music notation and instructions. **Content** Use one of these attacks on the following sequence of notes, selecting afresh for each one individually, long pauses between notes. When all notes of the instrument have been played, select additional notes at random, either on or off the instrument.

CC25 15.7.69 Two staves of music notation in ink, the second intended to be a retrograde of the first. The second line crossed out in pencil and a third stave added in pencil giving the correct retrograde of the first. **Content** In neon lights.

CC26 16.7.69 At (1) a stave of music notation with the text below arranged to fit the music in two different ways. **Content** 2 Themes. (1) To/know/what precedes and what follows. To know what/ precedes and what follows. (2) "It is the unusual that is most deserving of our interest". Discuss, with reference to the idea of "Central importance". Are problems created by equating 'peripheral' and 'unusual'. Comment on your conclusions.

CC27 19.7.69 Ink drawing of a smiling head with features numbered 1-23. **Content** Making faces. (Mirror optional)

CC28 20.7.69 A stylised ink drawing of the open scratchbook with integrated lettering saying what it is and that the right hand page is blank (CC28 is in a left hand page). The left hand page in the drawing has a green smudge. **Content** *Make a model.* Choose a scale. Modes of representation. The model is a transient structure representing a more permanent structure temporarily occupied for the purpose of making a concert. The model is a model of its own environment. Attend to how the model itself is represented in the model — by a cipher, or by the same rules of representation used in making the model, or by different rules. A model can never be completed.

CC29 21.7.69 **Content** Find or make a peak or vantage point. Survey past and future from it.

CC30 22.7.69 The page is divided into columns by 11 vertical lines. In the top of the left hand column is the numeral O. **Content** Count! list interim totals:

CC31 24.7.69 3 lines of rhythmic notation. **Content** "Flip Flop". The unit rests before accents are optional in every case. In cases where the rest is used the following accent becomes optional. Sequence of numbers of beats is random/arbitrary. The above is percussion. Long vocal sounds may be used simultaneously, related or unrelated to the percussion spectrum.

CC32 27.7.69 Diagram of a chess position. **Content** *Twilight. Chess Game.* Find an opponent. Finish this game and play further ones until bad light stops play. Notate new position.

CC33 4.8.69 **Content** DIE

CC34 6.8.69 **Content** Pick quarrels. (Arouse animosity) by 1) Insult 2) the unobeyable command 3) wilful misunderstanding 4) disturb a tete-a-tete 5) 6) 7) 8) 9).

CC35 7.8.69 Music notation for bunch of bells, timpani, bass drum, cello and contrabass. **Content** Ostinato

CC36 8.8.69 Obscure music notations in lower part of page. **Content** *Work on the Scratch*

Orchestra Song. To be called "Let's call the whole thing off" (apparently the last line of an existing song lyric). Can be sung to already existing melody, but better to invent one. Collect phrases for lyrics, eg. "why don't you drop dead". Line 2. It's a bad habit; — a complete waste of time. Scratch the Scratch song and hear it drop — dead. Voice part: "Medium mumble". Percussion part: "very strong"

CC37 9.8.69 **Content** Cow (Sheep, Goat) Bell(s). at a distance.

CC38 14.8.69 **Content** Spider. Make a web. (look for a book of webs).

CC39 16.8.69 The Text divided as in music into 4 bars repeated over and over. **Content** climb up / survey the land / descend / survey the heavens.

CC40 17.8.69 **Content** Bees.

CC41 18.8.69 **Content** Play on the Stone Chimes with the stone beaters.

CC42 20.8.69 **Content** *Attempt* Having no control whatever. Just reacting.

CC43 21.8.69 Between two pages about a dozen leaves from a diseased tree, each leaf in a different stage of decay. The two pages are taped together with masking tape. **Content** Progress of a disease. Progress of a mechanical fault. Progress of a consuming love. (the following is added in pencil) plus: progress of a calculation error / progress of a lying word / progress of a mesalliance / progress of a vendetta / progress of a destroying fire / progress of an erosion (These not readily performable except as film, projections, etc.) *Irreversible processes*

CC44 22.8.69 At lower left an ink drawing of the business end of a mason's chisel with a notch out of it. The missing part is shown by a dotted line. **Content** Broken tools.

CC45 31.7.69 In the lower part a diagram of a 4-place matrix with negative and positive result in the left margin and short and long term in the upper margin. Pencil arrows show the four possible combinations and project them to a column at the right, headed "date". **Content** The invariant negative response. Tabulate results according to the following schema: (diagram) positive result, negative result, short term, long term, date.

CC46 15.8.69 **Content** *Sentimental journey.* Remember. . . (substantiate the memory). Recall?

CC47 6.9.69 **Content** Appropriate cleaning methods. (erosive) washing/wiping/scraping/ tidying/polishing/brushing/sweeping/grinding/ sanding/burning/steaming/licking/scratching/ weathering (renovative) painting/veiling/ varnishing/furbishing/decorating/encrusting/ binding/sewing/embroidering/fueling/oiling/ greasing/covering/lubricating/wetting/spraying.

CC48 7.9.69 **Content** *On foot* Morning walk/ mid-day promenade/Evening stroll/Night prowl (Various runs)

CC49 8.9.69 **Content** Listen — seduce

CC50 14.6.69 **Content** CONTINUALLY: look upwards. OCCASIONALLY: something happens.

CC51 13.9.69 **Content** *Appeal* Give/Spare/Lend/ Tender/Throw/Hand me a note/word/name/ kick/kiss/light/problem/insult/thought

CC52 14.9.69 **Content** *Virtuosity* Develop a skill. Legerdemain eg. in the handling of a sledgehammer. Able/Unable to do something properly/more or less/not at all.

CC53 15.8.69 **Content** *If all else fails* Explain and teach someone (uninitiated) how to set about making scratch music.

CC54 12.6.69 A page of sentences of increasing complexity using the elements listening (or feeling), thinking, playing, resting, counting (the last is indicated but not used).

Content While listening (or feeling) introduce a further listening (or feeling). While listening (or feeling) introduce thinking. While listening (or feeling) introduce playing. While listening (or feeling) introduce resting. While thinking introduce listening (or feeling). While thinking introduce playing. While thinking introduce resting. While playing introduce listening (or feeling). While playing introduce thinking. While playing introduce resting. While resting introduce listening (or feeling). While resting introduce thinking. While resting introduce playing. While resting introduce a further resting. While thinking introduce a further thinking. While playing introduce a further playing. While listening (or feeling) introduce thinking and playing. While listening (or feeling) introduce thinking and resting. While listening (or feeling) introduce playing and resting. While thinking introduce listening (or feeling) and playing. While thinking introduce listening (or feeling) and resting. While thinking introduce playing and resting. While playing introduce listening (or feeling) and resting. While playing introduce thinking and resting. While resting introduce listening (or feeling) and thinking. While resting introduce listening (or feeling) and playing. While resting introduce thinking and playing. While listening (or feeling) and thinking introduce playing. While listening (or feeling) and thinking introduce resting. While listening (or feeling) and playing introduce thinking. While listening (or feeling) and playing introduce resting. While listening (or feeling) and resting introduce thinking. While listening (or feeling) and resting introduce playing. While thinking and playing introduce listening (or feeling). While thinking and playing introduce resting. While thinking and resting introduce listening (or feeling). While thinking and resting introduce playing. While playing and resting introduce listening (or feeling). While playing and resting introduce thinking. While listening

(or feeling) introduce thinking and playing and resting. While thinking introduce listening (or feeling) and playing and resting. While playing introduce listening (or feeling) and thinking and resting. While resting introduce listening (or feeling) and thinking and playing. While listening (or feeling) and thinking introduce playing and resting. While listening (or feeling) and playing introduce thinking and resting. While listening (or feeling) and resting introduce thinking and playing. While thinking and playing introduce listening (or feeling) and resting. While thinking and resting introduce listening (or feeling) and playing. While playing and resting introduce listening (or feeling) and thinking. While listening (or feeling) and thinking and playing introduce resting. While listening (or feeling) and thinking and resting introduce playing. While listening (or feeling) and playing and resting introduce thinking. While thinking and playing and resting introduce listening (or feeling). Add the element 'counting'. Underline elements used. I think Emmett Williams is source of this (or Watt).

CC55 17.9.69 Inspiration: (Keith Rowe). **Content** *Conductor* Select a person nearby and play him — his dress/gestures/physique/expressions. You may advise him of what you're going to do or not.

CC56 2.11.69 **Content** Positioning / (Position people. . . Arranging / (Arrange objects. . .

CC57 27.11.69 **Content** Look upward. Walk backward.

CC58 19.3.70 **Content** Make sounds that are a) inaudible to you b) inaudible to anyone except you. Make movements that are a) invisible to anyone except you b) invisible to you c) invisible to everyone.

CC59 Printed 10.7.70 **Content** Michael Chant's Pastoral Symphony. (Try and understand it).

CC60 Received 30.7.70 Suggestions for Wedding Photos. **Content** Groom and Best Man

arriving / Bridesmaids and/or Page Boys arriving / Bride's Mother arriving / Bride arriving / Signing register / Walking down aisle / Horseshoes at door / Bride and Bridegroom alone, 2 or 3 positions / Bridal Group, i.e. B & B., Bridesmaids, Best Man. etc. / Parents with previous group, "Grans," included / Family group with both families / Bride's family group / Groom's family group / General group including all guests / Group of Ushers / Guard of Honour group (if any) / Couple walking away (perhaps procession)/At car door / Inside Car / Cutting cake /

CC61 25.8.70 **Content** 'Cello. Look through a telescope (long bow with maximum diminuendo) and describe the configurations you see (harmonics)

CC62 25.8.70 CC62-67 are written in charcoal and the words of facing pages print off onto each other. **Content** Continue the search for a life apparently eventless in which everything is happening.

CC63 26.8.70 **Content** Practise death in order to play life (practise low notes as preparation for playing high ones).

CC64 26.8.70 Inspiration: (M. Chant) **Content** *Sitting* Sit still in a position. Time your stillness. Find another position and sit still in that. Time your stillness. Some still positions may have an active component, eg. lounge with 2 fingers drumming. Straight Pharoah sit with winks.

CC65 26.8.70 Music notation of a semibreve A-flat below the bass stave. **Content** Play long lengths of this note. Time the lengths. Notate the timings. Play (use) the notations.

CC66 28.8.70 Inspiration: (Dave Jackman) **Content** Make a musical instrument. Don't try it or play it.

CC67 28.8.70 Inspiration: (Wolff). Includes music notation of B & D in treble clef as a resounding quaver at the word 'pizz.' **Content** *Master Musician* makes the sounds made by musicians into music (by hearing them aright) He makes the sounds around him musical (by hearing them aright). Occasionally he may add a touch, a pizz, a belch (very occasionally).

CC68 9.10.70 Inspiration: (Autism. Mantra. . .) Includes music notation of repeated D's in treble clef at 360 to the minute, a series of random digits without zeros indicated to continue indefinitely, and lower down, rhythmic groupings for the various circuits. **Content** *Piano* ('Pulse machine') (a tempo fast enough to have light vitality) (a note high enough to sound bright) (a series of random digits without zeros). First circuit: / Second circuit: / Third circuit: / Fourth circuit: / Fifth / etc. / (a system of repeats designed to extend the material indefinitely). Play with the regularity of a machine. The only permissible accents are those that occur involuntarily. The notes are grouped mentally only.

CC69 Received 11.7.70 from Judith Euren. A rectangle of blue-lined paper with red margin, with writing in blue biro, glued in. A column and a half containing the letters RWD in random sequence — 23 letters in all. **Content** R — Run, W — Walk, D — Dawdle. Duration of each section — 1 min.

CC70 8/9.10.70 Incomplete (later completed for Tom and Jill Phillips wedding anniversary) music notation on 4 staves of OUR JOY, ode machine by C. Cardew (Karlgren 56). *Lyric* (in 3 verses): 1) Our joy is fulfilled in a valley by a stream / My stately man, oh you are gentle / Away from me he sleeps he wakes he talks with friends / Forever, he swears, he will not forget me. 2) Our joy is fulfilled on the sloping hill / My stately man, oh the size of you / Away from me he sleeps he wakes he sings his songs /Forever, he swears, he will not turn away. 3) Our joy is fulfilled on the high ground / My stately man, oh you stand out / Away from me he sleeps he wakes in his own bed / Forever, he swears, he will not betray our love.

CC71 25.11.70 **Content** Playing scales.

CC72 4.12.70 **Content** Consume a packet of Smiths Crisps.

CC73 A small ink drawing and larger pencil drawing on tracing paper, glued in. Both drawings represent a superimposition of the Chinese characters occuring in paragraph 4 of the Great Learning.

CC74 A diagram in ink on tracing paper, glued in. 11 lines ray upwards in a fan shape from a point at the bottom. Current exchange values of different currencies are shown by horizontal lines to left and right of the fan shape. The amount represented by each division in the fan is shown in brackets after the currency. **Content** (from top to bottom): Yen (100s), DM (1s), £ (.1s), NF (1s), Lire (100s), Norway Kr (1s), Danish Kr (1s) Rbles (.1s), US $ (.1s) Canada $ (.1s), Czech Kr (1s)

Stella Cardew

(Items selected from two Scratchbooks doubling as notebooks and sketchbooks)

SC1 **Content** Yesterday I wanted to buy the red-pink frilled stamped heeld lace up shoes and the black plastic lace hat with a red rose on it.

 To go with plain dresses!

SC2 **Content** I didn't buy the hat when I went back there the second time — the first time was 9 oclock on Wednesday morning with Freda and then we went across the river — they only had a huge black hat with a lot of flowers. But I bought the shoes only they

were rather very red but a beautiful red vermillion but they wern't very leg making. today at last I got the ladder cutters and string and cut and tied up the roses so they cross the front of the lawn again.

 Now I think I'd rather try and make an etching of the oak tree than write this.

SC3 **Content** I haven't worn the red shoes. They are very hot.

 Ive got Freda's black jersey trousers and white plimpsoles.

 Ive cut one rambler and tied it up with string but the other had buds on it already. There are heaps of earth choking the flowers in lots of places that I must try and dig off. All the earth in the boarders looks very dirty. The lawn looks lumpy.

 I don't want to dig anywhere because of the forget me nots.

 What's out. Aubrecia
 blue bells.

SC4 **Content** I looked out of my window over Rosemary's lawn — something I hardly ever do on principal, and her lawn was very hard cut and I thought it looked beautiful like an old English garden kept by servants so she lent me her lawn mover and I cut ours hard but left some long corners. I wonder how it will look now. They'll be masses of different flowers out — even golden rod and white daisies and sweet peas. But this is the Triumph of the year (and no one there to see it) I think I should do something to make it look more interesting — less (continued in SC9)

SC5 Child's drawing in black ink and blue biro over two pages. The two media are used by different children. The black uses the blue as if it were a map of a country district — perhaps with small industry, a quarry or something — and inserts on it a railway layout.

SC6 Child's drawing of warships. Felt tipped pen. Twelve ships are visible, one of which has

been sundered amidships and is going down fast.

SC7 Drawing of five Second World War type planes. Format is horizontal and four planes are arranged stacked up with propellers to the left. They are numbered from top to bottom 3 1 2 5. The fifth plane is on the right side pointing upwards. It is numbered 4.

SC8 Nine more planes, these mostly in process of landing and taking off.

SC9 Continuation of SC4. **Content** gappy all the year round.

I don't know what to pull up as it is. Where the worst patches are.

I would like to smuggle some lavender home — also thyme of course

Now I have a bunch of everlasting flowers via eterna. and thistles but I must get more.

So I cut the lawn before I left. and I tied some plants up. That is I found soft wire that held in circklets onto itself, but I think that put more strain onto the roots. then I found the stakes along the wooden fence meant for the rasberrys. So I began to string them up from plant to plant and bush to bush — if one came down the rest would fall like nine pins. But anyway I couldn't bang a stick in the ground was too hard.

I also shirked going in behind the second rose climbers I can see quite clearly now that it is full of woodland weeds — but the brambles and rose thorns were too thick. But I must plant something when I go home. Because the weeds don't have many flowers. just tiny spears of pink — or white I can't even see the colour they are so small.

For roasting potatoes you need flat stones and ash. let the fire go down rake off the ash and put the pots on unwashed and unpricked cover them with ash and they will be cooked not blackened and so sweet in half an hour of so.

Now Phillip says dig a pit heat stones in a fire lay them very hot in the bottom of the pit cover them with wet sacking then put all the meat and vegetables into the pit — I think you cover it with more sacking and a stone? I don't know the end we are going to try it.

No wrap in big leaves then more sacking then dirt.

SC10 Child's drawing. Two (?) concentric enclosures, the outside in blue and red felt tipped pen, the inside one in black and green.

SC11 **Content** I don't see what an accompaniment is.

a jar with a good few very hard resinous beetles from Ansedonia hard black and brown etchings with big shapes (how?)

careful photogenic realism!

colour practises with restricted range.

Then pose models for ten minutes paint what strikes you most what you most want to put down about what you see. Change the pose — continue painting.

When model has gone you can change lines and shapes and blocs of colour still keeping within the range I expect unless you feel something else imperative.

Ask Tom or David Spiller or Wolfie about eg the cigarette painting.

SC12 **Content** Accompaniment. Rubbings — say four rich squares. Pinking method press the insects into very soft beeswax ground — remove — bite and print.

Get newspaper aluminum sheets — scratch through the chemical on the back. Engrave with a burr.

SC13 Child's drawing in blue biro.

The following selection from the second notebook; the material is not conceived directly as Scratch Music.

SC14 List of themes for etchings. **Content** Comics / rooftops — to be finished / rosedrawnover / insects / cards / ruler / everlastingfrancedrawnover / graveyard from

a distance roughly done / mysterious branches / rooftops mysterious / get an idea from Pierro's film / flags and nudes / skylines / light green or brown scenes thru dark archways doorways etc / spider's webb / record breakers / back garden.

SC15 Two pencil drawings of a nude girl exercising in front of the US flag.

SC16 Coloured drawing of the same. The figure is facing you with arms stretched up. Stripes to the right, stars to the left.

SC17 Another coloured drawing. The figure is crouching.

SC18 Child's drawing in coloured crayons. At the top the word 'England' in green. In the centre, large concentric circles of red, white and blue and yellow. Bottom right: concentric circles, in red and blue. These are modelled on aeroplane wing markings. Bottom left a Union Jack on a brown pole.

SC19 A closer view of SC17, more crouched.

SC20 Child's drawing in coloured crayons. Blue strip at top represents the sky. On a brown pole, a tricolour (?French) flag: Red, white, blue. **Content** (handwritten on the facing page) Horace said it's my best colouring. I don't want to spoil your book.

SC21 Pencil sketch of roofs, etc. **Content** (in pencil below) Backs/squares crossed/and skyline.

SC22 Soft pencil scribbled design (clouds), rubbed to give soft shades of grey. A space in the middle contains four soft grey blobs.

SC23 Five of hearts. A large one in the centre and four smaller ones in the corners. Surrounding it a grey round-cornered rectangle. The hearts are in coloured crayons — a mixture of magenta and vermillion.

SC24 Five of spades. As SC23 except the spades are all the same size, the centre one pointing downward. Colours: black and dark blue.

SC25 Five of diamonds. As SC23 Colours: orange and red.

SC26 Five of clubs. As SC23, but the lower pair grow downwards. Colours: grey and pink.

SC27 Giant figures of a single spade, heart, diamond and club are superposed in coloured crayons as SC23-26. The grey round-cornered rectangle is also there.

SC28 Design in coloured crayons based on suit symbols. Shades of green, blue, yellow.

SC29 Design in coloured crayons, based on suit symbols. Yellow, blue, grey, white.

SC30 Design in coloured crayons based on suit symbols. Pink, blue, yellow, green.

SC31 Pencil sketch of unidentifiable forms. Just a few lines.

SC32 Crayon drawing of a jug with flowers. Grey, cream, purple. SC31 is now recognizable as a sketch of the same subject.

SC33 List of themes for etchings. **Content** Fountains / Spiders webs / more numbers / Rough winds do shake the darling buds of May / Shirt one again.

Further elements in the Scratchbook that could be interpreted as Scratch Music: **Content** Squares round numbers / very faint and not to do with number / numbers hidden / numbers very clear (SC34). Time to write (SC35). Clouds (SC36). clean up. / all broken glass / scavenger hunt / Bring back during a certain time. / prize /. List. grasshoppers / How to let them know. / tyre race. / Obstacle race / hide and play. (SC37).

Carole Finer

Scratch Music 1969

CF1 **Content** Water Music. Only make sounds connected with, or made directly with water. Also any sounds made entirely underwater, or half out and half in water. Also water-aided instruments such as bird warblers.

CF2 **Content** Rustling leaves, dry grasses, dry flowers, bamboos, reeds, rushes, tafetta, silk, tissue paper.

CF3 **Content** Rolling Sounds — sounds made with any round, rolleable objects, rolled round trays, saucepans, the floor, etc, sounds to be smooth and continuous.

CF4 **Content** Instrument (and voice) practise. All forms of scales, arpeggios, chords, standard exercises, practise-pieces from music teaching manuals.

CF5 **Content** Guy Fawkes Night Scratch Music. Guys, bonfires, children, darkness, surprize, food, hot drinks, excitement, matches.

Scratch Music 1970

CF6 **Content** People-Influenced Music — One specific sound when people enter. Another when people leave. Another when people speak. Another when people look at you. Do not make any other sounds. If too many events occur at once, make a note of the sounds and play them later. Rules of play can be changed to suit different circumstances, for instance, play something when people enter a specific area of the room, or play something when a particular instrument is heard.

CF7 **Content** Build a carpet with coloured papers, or coloured ribbons, or coloured sticks.

CF8 **Content** Bow the banjo to produce perfect sounds.

CF9 **Content** When the music is very loud indeed: play and sing folk songs. No-one else should hear.

Scratch Music 1971

CF10 **Content** Have between six to twelve whistles. Play all of them at least once.

CF11 **Content** Lazy Scratch. Take a mat and a cushion. Arrange instruments within easy reach for when lying down. Play now and then, lying down. Go for a walk to see what others are doing now and then, maybe play an instrument while walking.

CF12 **Content** Paint a carpet or part of a carpet.

CF13 **Content** Lazy Scratch No 2. Copy other people. Play and act what others are doing. Be as unoriginal as possible. (Selecting who to copy could be too active, maybe copy people in some sort of mechanical order, such as alphabetical, etc.)

CF14 **Content** Invent a private journey and go on it.

CF15 **Content** Crochet little coloured flowers to give to people.

CF16 **Content** When the music is very loud indeed: Play the blues. No-one else should hear.

CF17 **Content** Be dressed all in one colour. BRIGHT GREEN? Have a number of discs, pieces of paper, objects, all in this one colour. Distribute these bits of colour throughout concert area. Ribbons, bits of material, wool. Lay the pieces around the floor, tie them on people, attach to walls. There should be fragments of the colour evenly dispersed everywhere.

CF18 **Content** Thread strings of beads to give away.

CF19 **Content** Be louder than anyone else at least six times.

Lou Gare

LG1 **Content**
I lay my saxophone on the curved table
why should I trouble to play,
it is such hard work, and there
aren't any breezes about today.

LG2 **Content** Using instruments or objects made
wholly from wood. make sounds. The I
Ching, 46. Sheng / Pushing upward. K'UN
— the receptive, Earth. SUN — The Gentle,
Wind, Wood. Within the earth, wood grows:
The image of Pushing Upward. Thus the
superior man of devoted character Heaps Up
small things, in order to achieve something
high and great.

Adapting itself to obstacles and bending
around them wood in the earth grows upwards
without haste and without rest. Thus too the
superior man is devoted in character and ne
never pauses in his progress.

57 Sun / The Gentle (The Penetrating,
Wind). Sun is one of the eight double trigrams.
It is the eldest daughter and symbolises wind
or wood; it has for its attribute gentleness,
which nonetheless penetrates like the wind or
like growing wood with its roots.

LG3 Sept 1970 **Content** It is like a big tree, a little
bird comes and sits in the tree and sings, it
doesn't make any difference to the tree. It is
a lovely day.

LG4 Drawing of a tree — the family tree of the
Archers **Content** (integrated lettering) Family
Tree. DAN DORIS (PEGGY) JACK (PAUL)
CHRISTINE PHILIP (JILL) (ROGER)
JENNIFER (NICK d.) LILLIAN TONY
KENTON SHULA DAVID ELIZABETH
ADAM

LG5 Poem by Amenemopet. **Content**
As for the heated man of a temple,
He is like a tree growing in the open.
In the completion of a moment comes its
 loss of foliage,
And its end is in the shipyards;
Or it is floated far from its place,
And the flame is its burial shroud.
But the truly silent man holds himself apart.
He is like a tree growing in a garden.
It flourishes and doubles its yield;
It stands before its lord.
Its fruit is sweet; its shade is pleasant;
And its end is reached in the garden.

LG6 3 Oct 1970 Two diagrams of SUN(**FIRE**),
RIVER(WATER), DESERT(EARTH),
TREE(AIR). **Content** QUARTERNIO
Leave your sanctuary and set off on a
journey across the great desert. It is very
hot, yellow-hazy and dry. The desert is
severely limited by the sun, everything is
baked and powdered into its basic con-
stituents and very little change is possible
— if any.

The river is beautiful — especially after
the aridity of the desert. Water is quite
miraculous in its fluidity and the opposite
of the barren rigidity of the desert. It is
alive and it brings life with it. Water is the
great mother of life, the elixer of life. The
mother river takes little notice of her
children, the green plants.

The desert cares nothing for the river,
the desert endlessly worships the sun; is a
child of the sun. The father sun warms the
river as impartially as he bakes the desert.

The leaves of the tree hiss continually in
the wind and sparkle incessantly in the sun-
light. The tree brings up all the cold dark
essences from the earth and transforms
them in the light of the sun. He is the uniter
between the dull earth and the fiery sun.

LG7 Nov 2 1970 **Content** String piece. The score
to be played is a string stretched from one
side of the room to the other. Audience are
one side, players the other. To play, a person
must cross from the audience side to the
playing side. To join the audience a player

must recross to the audience side. Players read the score from one side to the other. Embellishments can be attached to the string, but if an embellishment weighs down the string another player can remove it or place a support to raise the string to its correct level. The string should be treated with due respect; if its breaks or is cut, or comes undone then the piece ends.

LG8 Nov 5 1970 Geometrical drawing in a square.

LG9 Black dots on a double page. **Content** White heavens with black stars.

LG10 Illuminated and normal lettering and decoration. **Content** Sound is invisible. Even within the chaos of sound, noise, music, one lives and moves freely in complete silence (LG 11Nov 1970). Loud noise is the same as silence (Gila, Oct 1970). I hope you will realise this during the play.

LG11 Nov 21 1970 Caricatures of different nose functions. Musical nose, illuminated noses, nose rest, nose lock, nose supporting a candlestick, dripping nose with tap, nose hanging in a corkscrew, nose packing a pipe, enormous spotted nose, nose with big black nostrils. **Content** Follow your nose for the duration.
Nose flutes can be played.
Players with long noses will be to the fore.
Some have a long way to go.
"Jesus said unto Moses
All jews shall have long noses,
Except Aaron he shall have a square 'un"
"Therein are his two nostrils like mighty
 galleries,
Whence his spirit rushes forth over all."
Musical nose. Illuminated noses. Nose lock. Nose rest.

Phil Gebbett

PG1 1-11-69 Graphic lettering. Roman numeral II in paradoxical 3-D. A large black letter C with a white 2 interlocked with its lower hook.

PG2 2-11-69 **Content** Make small percussion sounds. / Interject pitched sounds — small — sparse. / Periods of silence — thought — consideration of environment.

PG3 3-11-69 Three systems each consisting of a horizontal line with black dots of various sizes arranged around it.

PG4 4-11-69 Scuffed colour postcard reproduction of Piet Mondrian: Composition in Grey, red, yellow and blue 1920. Oil on Canvas 39" x 39" (Tate Gallery).

PG5 5-11-69 Extract from Luciano Berio's Sequenza for solo flute (music notation).

PG6 6-11-69 **Content** Think of a person (a particular person — preferably someone you know): / Play that thought, and thus experience it more fully: / Think again: / Play again: / Think of another person, or the same person: / Continue as above:

PG7 7-11-69 Three systems each consisting of a horizontal line with straight-line geometrical shapes arranged around it.

PG8 11-11-69 Musical and non-musical symbols drawn at random over the page.

PG9 12-11-69 **Content** EINSTEIN E-E / KANT A / WITTGENSTEIN G-E-E / KLEE E-E / POLLOCK C/ BERIO B-E (B-flat — E) / BACH B-A-C (B-flat — A-C-B) / MONDRIAN D-A / SARTRE A-E / KAFKA A-F-A / DIRAC D-A-C / CAGE C-A-G-E / G.M. HOPKINS (B) / STOCKHAUSEN C-A-E (C-B-A-F) / HOLLIGER G-E (B-G-E) / TILBURY B (B-flat) / CONFUCIUS C-F-C / BASHO B-A (B-flat — A-B)

PG10 22-11-69 Extracts from Cathy Berberian's Stripsody (graphic notation)

PG11 23-11-69 **Content** Walk music. / Movement music. / Stop — watch — listen. / Continue.

PG12 26-11-69 Graphics: in the centre a cluster of dots. Around this a whirling circle with three arrows leaving it tangentially. At bottom left an arc of a much larger circle.

PG13 23-12-69 **Content** Ludwig Wittgenstein: "Ein Ausdruck hat nur im Strome des Lebens Bedeutung" (An expression has meaning only in the stream of life).

PG14 28-12-69 Monodic music notation using only the notes G A B C D E F in treble clef, based on HAMM — from End-game by Samuel Beckett.

PG15 13-10-70 A 15" detail from The Waste Land (Tim Souster) for sax, piano and electric organ (music notation. It appears to be a programme illustration, and the following programme details are also included). JOHN WHITE P.T. Machine / CORNELIUS CARDEW The Great Digest (par. 6) / STOCKHAUSEN Abwärts, for ensemble (excerpt from Aus den sieben Tagen). 1st London performance.

PG16 13-10-70 **Content** Play one sound. / Repeat it. / Repeat it. / Continue repeating it until it bores you. / Repeat it. / Repeat it. / Continue repeating it. / Stop. /(Listen to your sound, each time you play it, regardless of the environment.)

PG17 13-10-70 **Content** Make a sound. / Try to reproduce that sound as accurately as possible on another / instrument (sound source). Try to reproduce *that* sound as accurately as possible on another / instrument (sound source). Try to reproduce *that* sound as accurately as possible on another / instrument (sound source). Continue as above until; / (i) you have produced sounds from every sound source available / to you at that time, / (ii) the sound has become as far removed from the initial / sound as is possible, / (iii) you become excessively bored. / (Do not use one sound source to make more than one sound.)

PG18 13-10-70 **Continue** Silence / — is it golden? / If it is enjoy it. / If it is not listen longer.

PG19 13-10-70 **Content** Add one sound, thoughtfully, / to the environment.

Bryn Harris

BH1 020769 Underlined handwriting, the four segments angled differently. **Content** Carefully think of a solo / then, whatever / you do, don't / play it.

BH2 030769 Handwriting in a small eggshape **Content** Shhhhhh not a word.

BH3 040769 **Content** Play to make the others sound like a gramophone record.

BH4 060769 Handwriting, the middle word getting larger then smaller. **Content** Pulcritudinous / SOSTENUTO /INTER-MEZZO

BH5 050769 **Content** Accompany members of the audience onto the stage, etc.

BH6 070769 Pencil drawing and handwriting, the last two words in fancy lettering surrounded by brightness lines. The drawing shows a 3-D zigzagging five-line stave vanishing to a point. At the front end a matchstick man instead of a clef. **Content** Don't get trapped like this poor fellow, use NEW NOTATION

BH7 080769 **Content** Look around / keep quiet / don't play!

BH8 090769 **Content** 23.59 + 1 ∴ no time for accompaniment!

BH9 100769 Drawing and lettering. Two scrolls, the right one a mirror image of the left. **Content** (left· scroll) MIRROR THOSE TO

YOUR RIGHT (the last word appears legible on the right scroll, and its mirror image on the left).

BH10 110769 **Content** If inside play the sounds from outside, if outside play the sounds from inside.

BH11 120769 Pencil geometrical drawing consisting of circles, arcs of circles and a petal pattern.

BH12 130769 **Content** Circles within circles, some concentric, some excentric, see them? Then play them!

BH13 140769 **Content** Tie a string round your finger, remember something, act in accordance with what you remember. Untie the string, forget. Stop.

BH14 150769 **Content** Improvise or rather extemporise on trumpet theme from Mahler's 5th Symphony. (Try to avoid creating an ostinatto.

BH15 160769 Drawing of a train carrying cattle straining forward along a five-line stave prefaced with a treble clef and ¾ time signature.

BH16 260769 Drawing of an amoeba (in pencil) ingesting a quaver (in ink).

BH17 280769 In red ink. **Content** Play something you think will please a conservative audience – watch the reaction of the other performers – if they look amused – continue – if they look annoyed – play another accompaniment – if they don't look – play louder – etc.

BH18 290769 Doubled lettering in red ink. **Content** DUPLICATE!

BH19 050869 **Content** Green – Play / Amber – Hesitate. / Red – don't play

BH20 080869 Plan of a birthday cake with 13 candles. A slice bearing one candle has been slid out to the right. **Content** This accompaniment is a piece of cake.

BH21 090869 Two staves drawn in black ink and filled in in red. The top one is preceded by a treble clef and is horizontal. The lower one is preceded by a bass clef and rises and falls in a curve like a boomerang: the middle three lines are absent at beginning and end of the lower stave.

BH22 110869 **Content** Post-impressionise / the proceedings.

BH23 120869 Handwriting and music notation giving three figures numbered 1, 2 and 3 to be repeated. The notations are marked 'legato, slow'. **Content** A definite ostinato, but beautiful. 1, repeat many times. 2, repeat about 8 times. 3, play one, two or three times. Play in order 1,2,3 then repeat ad inf.

BH24 179769 **Content** Play to the promenaders, whether in the arena or the gallery.

BH25 180769 Two shoe prints drawn in outline on a noughts and crosses layout. At right, a signature. **Content** J.W. Turner.

BH26 190769 Groundplan centering on door two of the Albert Hall (marked with an arrow).

BH27 010969 18 dots in a horizontal line alternately black and red. Above the row all the red dots are bracketed with a black line, with red handwriting above. Below the row all the black dots are bracketed with a red line, with black handwriting below. **Content** (red) Colourful (sic) (black) music

BH28 030969 Stencilled lettering. **Content** BRYNSOSTIP

BH29 040969 **Content** Flute ossia part part played on piano by foremost authority. Why?

BH30 140969 **Content** Private? Company

BH31 260969 The numbers 60 60 24 7 4 or 5 (on the line below) 4 12 (on the line below) 13 10 10 are written in a horizontal line with pencil dashes connecting each with its neighbours (whether on the same line or below). 24 and 12 are bracketed in pencil, the bracket being broken by the number

365.25 (in pencil). to the left of the number 60, 1000 1000 has been written in pencil with connecting lines as above.

BH32 300969 **Content** Slave's explosive box, 1d or 3d.

BH33 071069 **Content** Graphic Onomatopoeia

BH34 081069 **Content** Revisitory copies

BH35 131069 **Content** Halve it with difficulty but / keep within the time limit

BH36 181069 **Content** This is an accompaniment in progress

BH37 191069 Large childish handwriting and at the bottom five notes of music notation in the bass clef (key of G). **Content** Etc. one Looked / Leaf at have / sometimes composer/ similar Canadian Music). / 1928 Developed / pedal-board. See Bowling. / books, Prague 'parts' followed / instructions Galilei. / Debussy / nature centenary / hoven under the / considered to Director

Christopher Hobbs

CH1 **Content** *Arboreal Rite* Imitate the tree. Be mindful of your roots. Strive to reach the light. Act in accordance with the seasons (creation, preservation, destruction (bringing forth), quiescence). Store within yourself the records of your past existence.

CH2 The digits 1-6, singly and in groups of 2 or 3 separated by commas, are arranged to be read horizontally in 21 rows each containing 7 digits or groups of digits, randomly selected. Horizontal lines and brackets connect similar digits in consecutive groups.

CH3 Four lines, complexly deviating from a horizontal norm, copied from 'Tristram Shandy'. The lowest line is annotated A,B,C, C,C,C,D in accordance with the book.

CH4 Two Chinese characters drawn in ink with a brush. The strokes are divided into 8 groups, which are coded with pencilled numbers, similar strokes (eg. horizontal ones) receiving the same number (in this case 3).

CH5 The words Tick, Pwssh, Brring, Bong, Ting, Bang, Bing, Pff,and Click arranged in random sequence, forming 6 columns, each containing 16 words. **Content** TICK BRING TICK PWSSH BONG TING / BRRING CLICK CLONK PWSSH BRRING PWSSH / BRRING BANG BING BONG PFF BANG / CLICK BANG PWSSH TICK BRRING BING / PWSSH BONG BING BANG PWSSH TING / BANG BRRING PFF BING PFF BRRING / BING CLONK PWSSH PFF TING TICK / BRRING TING CLICK BING CLONK BRRING / TICK BONG BONG BONG BING BRRING / PFF CLONK TICK CLONK CLONK TICK / TING TING CLICK BANG PFF BONG / BRRING CLONK BONG BRRING CLICK CLICK / BONG BING BANG CLONK BANG PWSSH / BING BANG BING CLONK TING TING / BANG BONK PWSSH BONG BONG BRRING / CLICK CLICK PWSSH BANG BRRING BONG

CH6 **Content** Take one object. Make sounds with it (let it emit sounds). Take a second object. Make sounds with the 2 objects. Take a third object. Continue, until there are no more objects or it becomes impossible to make a sound which involves all the objects. Then take away the first object, and make sounds with the remaining objects. Take away the second object, and continue, until the last object added is left on its own. / Peas, etc. thrown onto cymbal, etc. Gather up peas which miss, throw these. Continue until all are on the cymbal.

CH7 **Content** *Event* Assemble an audience by the side of a road, or a river. After it has been waiting for some time, a piano is driven past (if a road) or carried past in a boat (if a river) – as fast as possible. The piano should be played continuously. Variation 1: Any sound producing means can be used. Variation 2: 2 lorries, boats, etc. drive past 2 sides of the audience simultaneously in opposite directions. (Below this in pencil:) (Piece).

CH8 Ink drawing. 6 horizontal parallel lines start (let's assume) on the left, then angle downwards getting apart and then resume their straight parallel path out to the right. In the course of the downward angle the lowest line moves from its original position to a new position above the top line. **Content** The 6-bar Gate.

CH9 Diagram collaged from magazine, sellotaped. To the left a vertical axis giving from 0-10 cms., with subordinate divisions, for the ½cms. Along the bottom a double-ended arrow marked 150mm.

CH10 Ten circles, 3 large, 1 medium, 6 small, numbered 1-10, randomly placed on the page. Intersections are emphasized with a dot (41 dots)

CH11 **Content** *(Scratch) Orchestral piece with Gramophone* A gramophone record of an orchestral composition, known to have a scratch in it such as will cause infinite repetition of one groove, is taken and played. The (live) orchestra accompanies the record, repeating the music heard to the best of its ability (what will come out is a sort of canon between the recorded and live performance). The record should preferably not be a popular classic. The performers must play quietly to avoid losing touch with the record, which should not be played loudly. When the record arrives at the repeating groove, the performers should, after a few repetitions, be able to play in unison with the record. The general volume level will probably rise, here. When a member loses touch with the record, he may go over to the record and jerk the needle on. This action should be plainly visible to the other performers, who must immediately resume their low volume and follow the record as before. The performance ends a) (if the gramophone is automatic) when the gramophone switches itself off, b) (if the gramophone is manually stopped) at any time after the record has ended. The audible click which sometimes occurs as the needle moves round the innermost groove may be taken as part of the record, in which case a similar situation to the one described above may obtain. The piece could be played by any performer(s), in which case the record should match as far as possible the instrument(s) or voice(s) used. Nov. 13, 11.37 pm.

CH12 **Content** *Television piece, for anyone* By way of example:– A pianist synchronises his concert with a TV broadcast of a piano performance. The TV should be placed so that he and the audience may see it (or more than one could be used). Volume should be turned down to zero. The pianist accompanies the broadcast, i.e. playing on the same keys (as far as possible) as the TV pianist, playing on the strings or the lid if the camera moves to these, or keeping silent in these places, etc. If a singer performs the piece, he or she should produce the sounds thought to be consistent with the facial expressions, etc. of the TV singer. If an orchestra performs the piece, each instrument should play only if the camera moves to it (in the case of 1 flute or 1 violin etc. being shown, only one must play – either decide beforehand who will play, or take it in turns. The whole orchestra should play only if all the orchestra is shown on the screen. Amplitude, etc. is free. The conductor should only perform if he is shown on screen, and should imagine that he is

conducting the TV conductor. This could be extended to other spheres (discussions, plays, newsreels, party political broadcasts, rallies, Trades Union Congresses, ballet, etc. etc. (Below this in pencil:) (Piece)

CH13 **Content** Shout one long loud note while walking in a place where there are many people. *Biblical Rite* Let not the left hand know what the rite hand is doing. Let not the rite 'end end until the left 'end has ended. 2nd version ; Let not the rite hand know what the wrong hand is doing. 3rd version ; Let not the neighbour on thy left hand know what the neighbour on thy right hand doeth. (All stand in a circle for this.) 4th version:

CH14 16 horizontal lines drawn right across the page with a brush. The brush was loaded only once with ink, so that towards the bottom of the page it is increasingly dry & the lines correspondingly broken up.

CH15 A graph clipped from a magazine. The curve ascends with increasing steepness from bottom left to top right. The curve passes through the intersections of the 5 units on each axis. **Content** Minimum Illumination required (Recommendation of the Illuminating Engineering Society) in lumens per square foot. (Vertical axis from bottom) 15,30,70, 150,300 lm/ft^2. (Horizontal axis from left) Rough work, medium work, fine work, v. fine work, minute work).

CH16 Horizontal diagram clipped from a magazine. The instrument shown is open at left & has a circular chamber at right. Two paths are shown by arrows from the circular chamber to the open end. They are symmetrical about a horizontal axis. The open end is barred by a dotted line. (The object is a pipe)

CH17 A page from a magazine sellotaped in. The page shows MS designs for light bulbs in four panels. **Content** (top left panel) Experiment No.1 Feby. 13 1880, 53 (illegible) small horseshoe. (Top right panel) July 5 1882

Sheet 2 Tar, Prevent Electrical (?) Carrying. (Bottom left hand) Mch 8 1883 Tar (illegible abbreviations). (Bottom right panel) Lamp Exp Edison & Thompson (bracketed). Edison's Exhibit G March 10 1883. Tar (illegible abbreviations). Carbon X, Aluminium X, Zinc X, Lead X, Magnesium X, Platinum X, Copper X, Silver, Phos Bronze, Babbit, Nickel X, Gold X, Silver (illegible), (illegible).

CH18 Graph with four lines coded differently, clipped from a magazine, **Content** (the four lines) Noises & Associations, Strange Situations, Animals (real), Imaginary Situations. (Vertical axis from bottom) Percentage fears 10,20,30,40,50,60,70. (Horizontal axis from left) Age in years 2,4,6.

CH19 Blank Crossword puzzle clipped from a magazine (without clues). 36 of the 144 squares are number coded. All squares are open. The symmetrical pattern is articulated by bold-line divisions between squares.

CH20 Newspaper clipping **Content** Who is she? A woman of about 50 found dead in a Nottingham hotel room apparently from a drugs overdose was still unnamed last night. (Below this in pencil) Who is she? Nov. 30 1969.

CH21 Newspaper clipping containing type & two drawings of Rupert Bear & friends. **Content** Rupert and Page Eighty – 51. Early that evening the four pals return to wait with Rupert by the bonfire. "The breeze has dried the wood," smiles Daddy, coming out with a box of matches. "It'll burn nicely." They all watch impatiently while the sky darkens, and at last the great moment arrives. "Here we go!" exclaims Mr. Bear. But as he is about to light the bonfire, he pauses and listens. "What is that swishing sound?" he mutters. A moment later there is a cry of amazement from Willie and the little group turns to see a bright object shooting across the sky. "Whatever is it?" gasps Rupert.

CH22 Map of the area south of Exeter, clipped from a magazine. Land is white, sea is puce. Dotted lines form enclosed spaces with 3 or 4 sides. There are 8 of these systems, all on the land area, three of them going off the map to left and top. **Content** EXETER. 31. 37. 41,42. 45,46,47,48. 50,51,52,53. 60,61,62. 70,71, 72. 75,76,77,78.

CH23 Map centred on the North Pole concerned with missile tactics, clipped from a magazine. A funnel-shape, shaded lighter than the rest, tapers from Asia to North America. Black (Russian) & outline (Chinese) arrows represent missile threats to USA. **Content** Possible deployment areas for SABMIS. CHINESE MISSILES. SOVIET MISSILES. Canton, Shanghai, Peiping, Seoul, Tokyo, Vladivostok, Irkutsk, Calcutta, Bombay, Tashkent, Novosibirsk, Yakutsk, Petropavlovski, Magadan, Nordvik, Vorkuta, Sverdlovsk, Teheran, MOSCOW, Murmansk, Attu, Anchorage, Edmonton, Churchill, Thule, Reykjavik, Stockholm, Oslo, Warsaw, Berlin, Istanbul, Cairo, Rome, Paris, LONDON, Algiers, Madrid, Lisbon, Montreal, NEW YORK, Chicago, New Orleans, Havana, Mexico City, Los Angeles, San Francisco, Seattle, Vancouver, Honolulu.

CH24 Drawing of a Friesian cow standing on grass, cut from a leaflet. Dotted lines show important divisions of the cow's body. Circled numbers from 1−37 have lines indicating particular parts of the animal.

CH25 Line drawing of a vertical cylindrical object, cut from a magazine. The following numerals are written beside arrows and lines indicating various parts: 12,20,32,18,16,33,12,37,19, 14,10,36 (reading clockwise from the top)

CH26 Large diagram cut from a newspaper; actually composed of two graphs, the first at top left, the second occupying the rest of the space. **Content** WALL STREET SINCE 1929. (Graph1) Daily average stock trading by months. (Vertical axis from bottom) 1−16 millions of shares. (Horizontal axis from left) 1940, 1941,...1970. (Graph 2) DOW JONES AVERAGES MONTHLY HIGH AND LOW OF THE AVERAGES. (Vertical axis from bottom, left side) 20,40,...400. (right side) 20,40,...1000. (Horizontal axis from left) 1929,1930,...1970. INDUSTRIALS, INDUSTRIALS (the top curve. Annual maxima & minima are given in figures to 2 places of decimals) UTILITIES (the lower curve. Treated similarly.).

CH27 Part of a blueprint glued in. It appears to represent some kind of slide-rule. On the reverse: mathematical data (Greek letters & Arabic numerals) written in pencil. **Content** (Sequences of numbers) 23−36, 123−131, 144−147 (27 numbers).

CH28 (?)Computer-drawn graph on a grey ground clipped from a magazine. It apparently shows brain activity over a 4-second period in which someone decides to turn on a TV, sees what's on & turns it off again. The graphed line fluctuates about a horizontal axis, at the left side it is mostly above the axis, at the right mostly below. A stylized picture of a brain is given at lower left. **Content** 20μV INTENTION. DECISION (written vertically, bottom to top) TV ON. RECOGNITION. TV OFF. 4 SEC.

CH29 Clipping from a newspaper (Hansard reported in The Times). **Content** in this important, and I do not need to stress, delicate matter,

David Jackman

All words are set in John Bull rubber type
SCRATCH MUSIC

DaJ1 3/6/69 **Content** SCRAPE WITH A STICK ON SOMETHING ROUGH, AND HUM SLOW CONTINUOUS GLISSANDI

DaJ2 4/6/69 **Content** SWITCH A TORCH ON AND OFF

DaJ3 5/6/69 **Content** SMILE, WHILE YOUR HUMMING TOP HUMS

DaJ4 6/6/69 **Content** VIBRATO

DaJ5 8/6/69 **Content** MAKE A SOUND USING GLASS

DaJ6 10/6/69 **Content** MAKE A LOW PITCHED SOUND

DaJ7 12/6/69 **Content** SET IN MOTION ANY NUMBER OF LOOP TAPES, OF ANY SOUNDS, OF ANY DURATIONS, VARY THE VOLUME LEVELS CONTINUOUSLY

DaJ8 13/6/69 **Content** SPORADIC HAND CLAPPING

DaJ9 14/6/69 **Content** MEASURE, IN AS MANY WAYS AS POSSIBLE, EVERYTHING IN AND RELATING TO, THE PERFORMANCE

DaJ10 15/6/69 **Content** BE KIND TO YOUR NEIGHBOUR

DaJ11 5/7/69 Offprint from coloured comic of Thor with winged helmet and yellow hair streaming in the wind, yelling. **Content** BE PRIMITIVE

DaJ12 6/7/69 Red lipstick print of a mouth

DaJ13 7/7/69 **Content** MAKE A DREAM OF PARADISE

DaJ14 8/7/69 **Content** CONSTRUCT A SITUATION IN REVERSE

DaJ15 9/7/69 **Content** CREATE A ZONE OF SILENCE

DaJ16 10/7/69 **Content** BUILD AN HIERARCHIC STRUCTURE. DESTROY IT, REBUILD IT, AND SO ON

DaJ17 11/7/69 **Content** MAKE AN AUTOBIOGRAPHICAL STATEMENT E.G. SHOW OFF

DaJ18 18/7/69 **Content** EAT, AND AMPLIFY THE SOUNDS

DaJ19 14/7/69 **Content** WHISTLE AIMLESSLY

DaJ20 15/7/69 **Content** MANIPULATE ALL KINDS OF PAPER. E.G. TEAR IT, BURN IT, CRINKLE IT, ARRANGE FOR A DOG TO LEAP THROUGH A PAPER HOOP, ETC

DaJ21 16/7/69 **Content** GET A BOX. PUT SOME-THING IN IT. SHAKE THE BOX

DaJ22 17/7/69 **Content** DROP THINGS

DaJ23 18/7/69 **Content** 1. PUSH SOMETHING ALONG THE FLOOR WITH A STICK. 2. TIE A STRING TO SOMETHING AND PULL IT ALONG THE FLOOR. A. DO BOTH SIMULTANEOUSLY. B. DO EITHER SINGLY.

DaJ24 22/7/69 Offprint from black and white image of a mouth singing into a microphone. **Content** MONOTONE VOCAL

DaJ25 23/7/69 Coloured offprints of metronome and electric bell with hands indicating how they function. **Content** HAVING STARTED SOMETHING, STOP IT. HAVING STOPPED SOMETHING, RESTART IT. . .

DaJ26 24/7/69 **Content** VERY SLOWLY TURN WHATEVER YOU ARE DOING AT ANY TIME INTO ITS OPPOSITE

DaJ27 25/7/69 **Content** PROCEED WITH A MISTAKE UNTIL IT SEEMS CORRECT

DaJ28 1/8/69 The three words are connected in a circle by three curved arrows pointing anticlockwise. **Content** WOOD → METAL → WATER →

DaJ29 2/8/69 **Content** BELLS

DaJ30 3/8/69 **Content** RATTLES

DaJ31 9/8/69 **Content** CHANT. ...FELL IN THE PIG TRAP MEANT FOR THE PIG THAT FELL IN THE PIG TRAP MEANT FOR THE PIG THAT...

DaJ32 12/8/69 **Content** THE SOUND OF BREAKING GLASS... ...TODAY I BROKE A WINDOW USING HIGH PITCHED SOUND

DaJ33 18/8/69 **Content** SLOW DEMOLITION

DaJ34 20/8/69 **Content** BOW A VARIETY OF OBJECTS

DaJ35 21/8/69 **Content** MAKE SOUNDS WITH A CYMBAL

DaJ36 22/8/69 **Content** MAKE SOUNDS WITH SPRINGS

DaJ37 23/8/69 **Content** INDOOR FIREWORKS

DaJ38 24/8/69 **Content** TELL A STORY

DaJ39 6/9/69 **Content** COMPLEX CLICKING AND TAPPING

DaJ40 12/9/69 **Content** COMMUNAL DRUM

DaJ41 18/9/69 **Content** IMPROVISED HORN

DaJ42 21/9/69 **Content** DRONE

DaJ43 12/10/69 **Content** BLUR AN EDGE

EARTH/AIR FIRE/WATER SCRATCHMUSIC IN THE WILD

DaJ44 5/7/69 **Content** TAKE 2 OR MORE STONES, AND TAP, SCRAPE, ETC. DIG A HOLE AND BURY THEM. OR PILE THEM, MAKE A CAIRN.

DaJ45 6/7/69 Small coloured offprint of a wood fire. **Content** LIGHT A FIRE, THROW IN COPPER FILINGS. . . GREEN FIRE. WHEN THE FILINGS HAVE ALL GONE, ROAST POTATOES IN SILVER FOIL, BOIL WATER AND SERVE HOT DRINKS

DaJ46 7/7/69 **Content** MAKE A DREAM OF PARADISE

DaJ47 8/7/69 **Content** MAKE IT RAIN. IF IT IS

RAINING ALREADY, MAKE IT STOP

DaJ48 9/7/69 **Content** GO FOR A SWIM... BE A FISH. IF THERE IS NO WATER, BE A MOLE

DaJ49 10/7/69 **Content** SWEEP OR GATHER LEAVES, GRASS, DIRT, ETC, INTO A PILE. MAKE A MONUMENT. PERSEVERE AGAINST WIND

DaJ50 11/7/69 **Content** BEAT THE EARTH WITH A STICK... DRUM FOR WORMS LIKE A THRUSH

DaJ51 14/7/69 **Content** SNAP AND CRUNCH TWIGS

DaJ52 15/7/69 **Content** SHAKE A LEAFY BRANCH

DaJ53 22/7/69 Black and white cartoon offprint of a dog's head looking at a bone hanging on a string from a tree. **Content** HANG FOOD IN THE TREES

DaJ54 1/8/69 The three words are connected in a circle by three curved arrows pointing anticlockwise. **Content** WOOD → METAL → WATER →

DaJ55 5/8/69 **Content** STRETCH A BLADE OF GRASS IN YOUR CUPPED HANDS AND BLOW ON IT

DaJ56 9/8/69 **Content** CHANT. ... FELL IN THE PIG TRAP MEANT FOR THE PIG THAT FELL IN THE PIG TRAP MEANT FOR THE PIG THAT. .

DaJ57 11/8/69 **Content** ORGAN. PLANT TUBES IN THE GROUND. BLOW ACROSS THE TOPS OF THEM

DaJ58 12/8/69 **Content** THE SOUND OF BREAKING GLASS... ...TODAY I BROKE A WINDOW USING HIGH PITCHED SOUND

DaJ59 18/8/69 **Content** SLOW DEMOLITION

DaJ60 23/8/69 **Content** FIREWORKS

DaJ61 24/8/69 **Content** COLOURED SMOKE

DaJ62 6/9/69 **Content** A SIMULATED OR ACTUAL

FOUNTAIN

DaJ63 12/9/69 **Content** COMMUNAL DRUM

DaJ64 18/9/69 **Content** IMPROVISED HORN

DaJ65 21/9/69 **Content** DRONE

PICTURES (the following series consists of coloured offprints from comic images)

DaJ66 28/7/69 Green mountain exploding

DaJ67 29/7/69 A burning stream of lava

DaJ68 30/7/69 Bubbling water

DaJ69 31/7/69 Beige, green and yellow; a volcano explodes upwards

DaJ70 1/8/69 Two legs beside a beige broom sweeping up purple metallic debris (the remains of a robot) on a yellow floor

DaJ71 4/8/69 Wreckage of a car on yellow ground

DaJ72 5/8/69 Close-up of a battle in outer space

DaJ73 13/8/69 Swirling, bubbling currents in the water

DaJ74 15/8/69 Close-up of debris burning

DaJ75 17/8/69 A shapeless alien's head in metamorphosis, radiating heat and light

DaJ76 18/8/69 A pair of giant, brawny blue legs are squarely planted in a smoking heap of rubble.

DaJ77 19/8/69 Monster's fists breaking through a restraining barricade

DaJ78 20/8/69 Yellow and beige ooze is raising itself up to do battle

DaJ79 24/8/69 Billowing smoke

DaJ80 25/8/69 Green and blue. Something hits the water violently

DaJ81 20/9/69 Smouldering crater

DaJ82 25/9/69 An explosion in the middle distance. The sky is red.

Diane Jackman Scratch Music

DiJ1 3.7.69 **Content** Scrape with a / one-end-open container / on surfaces.

DiJ2 3.7.69 **Content** Roll containers along the ground / with balls, bells, marbles etc. inside.

DiJ3 4.7.69 **Content** Take one large box of smarties and make noises with it. At random intervals take a smartie out of the box and eat it so that the noise gets less in the box, but more in the stomach.

DiJ4 11.7.69 **Content** Take two tin containers / half filled with water and / pour one into the other.

DiJ5 16.7.69 **Content** Take a tin full of / marbles, take them out / and roll them on the floor.

DiJ6 18.7.69 **Content** Take a closed cylinder / (empty pepsi-cola tin). Bang it. Drop things / through the holes the / pepsi came out of.

DiJ7 1.8.69 **Content** Fly musical kites.

DiJ8 15.8.69 **Content** Play fivestones with pebbles. / Play fivestones with bells.

DiJ9 21.8.69 **Content** Light candles that smell nice. / Light candles that glow different colours. / Light candles that spark.

DiJ10 22.8.69 **Content** Make sounds with / chocolate box packaging.

DiJ11 23.8.69 **Content** Tear up different sounding / paper into patterns, palm-trees / and confetti.

DiJ12 15.9.69 **Content** Small explosions / Bangs and pops.

DiJ13 4.10.69 **Content** Chimes in an airstream

DiJ14 8.10.69 **Content** meditate upon a stone

DiJ15 10.10.69 **Content** prisms of light / incessant bell

DiJ16 11.10.69 **Content** clap in waltz-time

DiJ17 12.10.69 **Content** Bounce a ball

Christopher May (the composer's selection).

CM1 Freehand drawing of nine rectangles arranged in a pattern and connected by lines marked as arrows. The general shape of the pattern is a large rectangle with a small rectangle inside it. The ninth rectangle appears in line with the top side of the large rectangle and above the rectangle at the top left corner of the small rectangle. **Content of rectangles** (large rectangle clockwise from top left) D, C-sharp, Unpitched, Free, G. (Small rectangle similarly) A-flat, F, D, B. (Connections indicated by arrows) D to G, C-sharp to D and G, Unpitched to C-sharp, Free to Unpitched and G, G to A-flat, A-flat to F and B, F to Unpitched and D, D to F and Free, B to F and D.

CM2 **Content** With a wind instrument investiagte on one note: (i) trills, (ii) flutter-tongueing, (iii) vibrato, (iv) tongueing, (v) humming while playing. After investigating each separately combine two or more.

CM3 The front of a blue envelope is glued to the page. The flap is exposed and open and below it there is handwriting. Inside the envelope are fourteen cardboard discs 7/8th of an inch in diameter with red numbers in red circles. The backs are blank. **Content** (numbers) 1 2 3 4 5 6 7 8 9 10 11 12 55 78. (Handwriting) Scatter the contents and interpret in any way. Repeat.

CM4 **Content** Play all the possible combinations of fingering on the recorder. AND/OR Play all possible combinations of two notes on the piano. ETC.

CM5 Chopped up fragments of xeroxed music notation are glued down in odd positions on the page. Other positions are occupied by handwritten words and dynamic markings.

The positions are connected by a network of arrowed lines similar to CM1. Orientation of music seems random. **Content** (handwriting) vivace, allegro, grave, moderato, adagio, ff, mp, mf, f, p.

CM6 A rectangle of paper is glued to the page at right, left and bottom to form a pouch. In the pouch are two squares of blotting paper liberally spotted with black ink. At some time this got wet and separated into blue and yellow blots. On one side of one sheet are a few doodlings in pencil — stars, circles, numbers, etc. A third square of the same size (roughly 4" x 4") is cut from transparent PVC and has two five-line staves set at an angle, boldly drawn with a red marker. This is also in the pouch. **Content** (handwriting on the pouch) Use the material in any way.

CM7 **Content** Listen to sounds. If they are high play loudly. If they are low play quietly. If they are loud play high. If they are soft play low. If they are unpitched contradict the rhythm.

CM8 **Content** (large letters in the middle of the page) FRAGMENT

CM9 **Content** Play a sound as nearly as possible the same pitch, duration, dynamics etc., each time. Never play it at the same point in space twice.

CM10 A negative image produced by some photocopying method. The page is upside down. The notation appears as a brown line with lighter edges on an off-black ground. Viewed through the back of the page it is seen to be music notation. (Piano reduction of the Dance of the Hours — only the space from the bottom line of the right hand to the top line of the left hand is shown.)

CM11 A diagrammatic drawing. Three circles contain letters. From the centres of these circles 7½" lengths of black cotton are fixed on the reverse side with sellotape. Two larger circles

contain crescendo and diminuendo signs. In
the lower part of the page two parallel
horizontal lines and a vertical line between
them in the centre make up two rectangles
each containing a letter. A smaller rectangle
sits on the top of the left rectangle. **Content**
(In the circles) F, D, D. (In the small rectangle)
P.T. (In the large rectangles) v, u.

CM12 Nineteen cut out small squares with musical
symbols in white on a light blue ground,
glued on. Five strips of blue paper with
parallel black lines, glued on. A system of
four numbers in circles connected by lines.
Two strips of 1" sellotape set at right angles
hold down thirtyeight cut out single letters
in bold sans serif condensed type. **Content**
(in circles) 1 8 13 6. (Integrated handwriting)
Love your enemies. Improve your technique.
(Cut out letters) A(x5) D(x2) E(x13) F(x1)
G(x4) H(x7) S(x6). (Handwritten note at
bottom) After the first performance of this
try to play it exactly as it was played last
time.

CM13 Sixteen circular holes of various sizes have
been roughly cut out of the page. One of
them damages the right hand edge of the
page. Nothing shows through from CM14
in the holes. The page can be turned over
and also used upside down. Only in the
reverse upside down position does part
of CM14 show through. (This accounts
for the roughly symmetrical design of
CM14).

CM14 48 roughly drawn squares in a roughly
symmetrical pattern. 16 squares are empty,
15 have zeros in them, 7 have x's, 7 have an
x in a zero, 3 are shaded. This coding of the
squares is not symmetrically patterned.

CM15 A square divided into four has numbers in
circles at the nine corners. Numbers and
mathematical symbols are liberally strewn
over the whole in a seemingly ordered way
(there are two crossings out). Besides arrow

markings on the line of the four squares
there are four heavy black arrows placed
diagonally near the top left, top right and
bottom left corners of the square, and near
the centre intersection.

CM16 On toasted paper showing streaky wet-marks,
an array of 14 x 14 squares, with integrated
lettering at top and left, and inside and out-
side the array, drawn in biro. **Content** (at
left, top to bottom, and at top, left to right)
A1B2C3D4E5F6G7. (In the seventh row
starting at column 5, one letter to a square,
left to right) INSIDE. (Below the diagram)
OUTSIDE.

CM17 Small squares, triangles and circles in red,
blue and black are inserted in a brickwork
pattern. There are seven rows of ten 'bricks'
(rectangles) each. The first, third, fifth, and
seventh rows project half a brick to the left.
A 'brick' may have 0, 1, 2 or 3 signs in it,
written horizontally. Assigning the number
1 to a red square, 2 to a blue one, 3 to a
black one, 4 to a red triangle, 5 to a blue
one, 6 to a black one, 7 to a red circle, 8 to
a blue one, and 9 to a black one, the contents
of the drawing may be described as follows.
Top row; 0 2 0 26 576 0 997 4 855 0. Second
row: 0 69 321 18 444 438 47 1 683 0. Third
row: 7 77 557 671 488 6 0 9 7 2. Fourth
row: 822 1 3 15 7 999 0 0 2 43. Fifth row:
4 77 957 0 0 0 51 7 15 241. Sixth row: 0 992
71 64 0 8 56 4 4 43. Seventh row: 37 0 0 659
52 685 0 64 88 78.

CM18 Coloured lines in four colours zigzag along in
apparently random fashion like erratic markings
on a temperature chart. Sometimes three are
interwoven, sometimes two. They proceed
from left to right through five systems. Some-
times a line abruptly changes colour. The
following is a description of the sequence of
events: Top system, line 1: green to yellow
to red. 2: blue. 3: (starts two thirds along)
green. Second system, 1: red. 2: blue to
yellow. 3: green. Third system, 1: red (ends

halfway along). 2: yellow. 3: green. Fourth system, 1: (starts after an inch or so) blue. 2: yellow 3: green to red. Bottom system, 1: blue (ends a couple of inches before the end of the system). 2: (starts halfway along) green. 3: red.

CM19 Four brightly coloured cards from a pack, glued on. The cards have numerical values. No 7 (top left) is a duck dressed like a dandy. No 6 (top right) is a (lady) pig promenading. No 3 (bottom left) is a city cock. No 4 is a bunny builder and decorator.

CM20 Two rectangles frame the key to their interpretation. Key: (red blob) STOP, (green blob) GO, (blue blob) LISTEN, (white blob outlined with biro) LEARN. The frames are composed of different sequences and different lengths of line in those four colours. Sequence of outside rectangle starting top left and going clockwise: (W=white, etc.) WRGRBRB WBRGBRBWB WRBGWGRWGR GWRBWBRGWRWRB. Inside rectangle: BWGWB WGBGRGWBWRBW RWRWB RGWGWRWGBWG .

CM21 Stick-on paper shapes in different colours, overlapping, make up an irregular design comprising four enclosures. The four lists given below give the clockwise circuit of each enclosure in turn. Sequence of items in common with preceding and following lists are underlined. (1) Black square, yellow circle, black lozenge, red heart, yellow diamond, black heart, blue diamond, green lozenge, blue square, black crescent, red triangle, green square, black circle, red crescent. (2) Yellow crescent, green circle, yellow square, red crescent, black circle, green square, red triangle, black crescent, red circle, green square, blue circle, yellow heart, red diamond, yellow lozenge, black square, green triangle. (3) Red square, yellow triangle, blue square, yellow square, red square, blue crescent, green triangle, black square, yellow lozenge, red diamond, yellow heart, blue circle, red lozenge, blue triangle, green crescent. (4) Green heart, black diamond, blue heart, green diamond, red heart, blue lozenge, black triangle, green crescent, blue triangle, red lozenge, blue circle.

CM22 Eight red numbers of different sizes and six typed quotations are cut out and glued down in apparently random arrangement. Parts of some numbers are obscured by quotations. **Content** 1 2 3 4 9 10 11 12. A good marksman may miss. Proverb/ Uniforms are often masks. Wellington/ Man has not a greater enemy than himself. Petrarch/ The first sigh of love is the last of wisdom. Antione Bret/ Above the cloud with its shadow is the star with its light. Victor Hugo/ Many can argue, not many converse. A B Alcott.

CM23 Two dots above, one word below. **Content** ictus

CM24 Red biro handwriting. **Content** BOUNCE REBOUND / take off. "Jump in," said the / air-man when he heard Herbert's / story, "I'm going your way."

So in Herbert jumped. It was / his first trip in an aeroplane and / he enjoyed every minute of it.

In a surprisingly short time the / air-man landed in the common / almost in sight of Herbert's own / home at Golliwog Villas. Her - / bert waved a happy good-bye to / the air-man as the plane flew / away again, then he strolled / home, and found Daphne Dolly /

CM25 **Content** (upper left) EXERCISE

CM26 Above left, two words. Below right a small circle with a dot in the centre followed by a tie. **Content** BE PREPARED

CM27 **Content** (red biro) CONSTANT DYNAMICS. PLAY AN INAUDIBLE SOUND UNTIL IT BECOMES AUDIBLE. (TO?). PLAY AN

AUDIBLE SOUND UNTIL IT BECOMES
INAUDIBLE. (TO?). REPEAT. (OMIT AT
WILL)

CM28 **Content** (red biro) LOOK – NO HANDS!

CM29 A sheet of computer printout. Three
horizontal systems of five quite widely
spaced dashed lines. Scattered on and around
these lines the letters C, P, E in endless
profusion. Near the beginning of the second
system a design of x's in ink representing a
treble clef. The x's are inserted in conformity
with the computer's ability to print them.
At the top of the page the word
MUSICMUSICMUSICM... (24 times) under-
lined with a dashed line.

CM30 Glued to a vertical strip of graph paper by its
left hand extremity is a slip of white paper
with roman numerals 1–48 typed on it in
three lines. 1–20 are on the first line,
21–34 on the second, 35–48 on the third.

CM31 One word in large black letraset in the
centre of the page. **Content** SING

Tim Mitchell

TM1 A photo of crater Copernicus on the moon
sellotaped into the Scratchbook. Names,
contours and gridlines have been superposed.
Content (contours) 4200 3900 4500 3900
3000 1800 2100 3900 2400 4500 4800
4200 4500 4800 3900 4400. 5200
COPERNICUS (3500). Copernicus A
Copernicus PA Copernicus Copernicus R
Copernicus H 4600 FAUTH (1100)
Copernicus N Copernicus B Copernicus BB
Copernicus BA Copernicus JE Copernicus JD
Copernicus JC Copernicus J Copernicus DA
Gay-Lussac J. (On the reverse in John Bull
rubber type) MOON MAP

TM2 A sheet of tracing paper sellotaped in contains
typelike handwriting in brown ink both right
way up and upside down. Also visible through
the sheet are TM3 and TM4. **Content** (right
way up) exhaust blast/ collect the matches
and place them one by one on the table/ So
that one tends to think of communication
between people as being dependent on their
capacity for exchanging information and
ideas by means of words, as though a rich
vocabulary and a good command of syntax
were all that was necessary to enable us to
make contact with one another. And as
though people who have no particular gift
for using (WASTED is written over the last
two words) words are thereby in some way
prevented from entering into a close harmony
with other people as inarticulate as themselves/
brush all but one match from the table/ We
hesitate to ask the question because we do
not wish to have the answer. Going about in
silence/ silent/ Reality has no limits. Search
for it. / a (x23) e (x39) (?calligraphic
exercises)/ Make a 'model' of the mixture of
gases that we call air. Different coloured
marbles or beads can represent the minute
particules of which we think these gases are
composed. Put them onto a tray, or a picture
frame backed with hardboard. In the air the

gases are all mixed up. What must you do to the marbles in your model in order to ensure that they too are mixed up — and stay mixed up!/ THE INTERIOR LANDSCAPE (upside down) The diagrams show where you can feel your pulse, and also a simple pulse indicator. If you put it on your wrist, where you can feel your pulse, it will rock backwards and forwards with each pulse beat. Take your pulse rate (a) when sitting down, and (b) after running about. Compare your heart-beat rate with your pulse rate. Does everybody have the same pulse rate?

TM3 Tracing paper sellotaped in. Writing like TM2 but generally right way up. One sentence written on the reverse. TM4 is also visible. **Content** It could have been stated more clearly/ The diagram shows how you can make a simple but very sensitive balance/ Can you devise a way of using this balance to compare the weights of a piece of steel wool before and after burning? What do you discover? Compare the weights of some other things before and after burning. Talk about the results you get with other people/ GREEN HOT WATER BOTTLE LEANING AGAINST THE WALL SO THAT IT IS BENT/ The knowledge of what I had just learned did not require that I direct my efforts according to the revelation in order to dissolve myself in an approximate contemplation. Quite simply, I could no longer avoid knowing what I knew, and, come what may, I had to pursue the consequences,/ The map or plan idea is needed before you start a journey. For this voyage I had a grotto, swamps and trees in mind. On a large sheet of paper laid on a table the grotto was indented by blue stylus and the rest of the paper covered with green powder colours. Then I drew the / move around/ swamp and the trees on other pieces of paper with soap and glass. Afterwards I cut them out with scissors and made paper

brackets to support them and stood them up on the paper with the grotto on it. On the left of the tree (central swamp) I placed a model explorer (self) made with odd scraps of stuff and plasticine./ oxygen bubbles going up/ at 5 fathoms/ at 10 fathoms (written in large outline letters) Running/ (written on the reverse) wander from room to room

TM4 Blocks of 100 letters printed from a (?) rubber stamp. 16 blocks of 100 a's in four rows, the two bottom rows overlapping. Then four blocks of 100 e's in a row below that.

TM5 Top: 12 or so blocks of 100 o's randomly superposed. Centre: five blocks of 100 i's, two superposed at right angles so that the dots coincide, two more at 45 degrees, also carefully arranged. Bottom right: three blocks of 100 n's superposed.

TM6 Typed list on pink paper sellotaped in. **Content** Consider a box./ Make a box./ wood/ nails/ hammer/ tennon saw/ electric saw/ drill/ drill bits/ screws/ glue/ plane/ spoke shave/ sand paper/ rubber disc for sand paper attachment for electric drill/ finishing sander attachment for electric drill/ brackets/ hinges/ chisels / mallet/ rawlplugs/ dowling/ paint/ brushes/ covering material/ stencils/ gig saw/ energy/ ruler/ pencil/ paper/ marker/ panel pins

TM7 Handwriting on pink paper sellotaped in. **Content** A person is to be considered as a stimulus for sound production. consider his head. the further it is from the ground the less complex the overtone structure for instance. ie if he stood on his head — play the most complicated overtone structure you could manage. consider his distance in relation to yourself. the nearer he was the softer you play for instance. A long way off and you play loud. Arms could indicate pitch.

Speed of movement — attack. Visibility —
Duration (if he went behind you or some-
thing which obstructed your view of him,
stop playing)

TM8 Top left: 100 n's and 100 o's superposed:
immediately to the right of this 100 i's and
100 n's superposed. Centre: small explosion
of e's, o's, i's, a's and n's. Bottom right: block
of e's and block of i's superposed, but
bleeding off right and bottom so that only
35 e's and 30 (complete) i's are on the page.

TM9 Black and white photo sellotaped in. A skier
taking off in a cloud of snow on a clear day
in the mountains. On the reverse: (pencil)
11176 (stamped) Verlag Klopfenstein
Adelboden.

TM10 Drawings on a piece of tracing paper sellotaped
in. TM11—16 are also visible. Top: typewriter
seen from above. Centre left: Lozenge-shaped
outline. Lower right: ?ornamental beadwork.
Lower still: five five-pointed stars of varying
size and design.

TM11 (Reverse of TM10 is now visible on the
facing page) Drawings on tracing paper
sellotaped in. ?Schoolboy sitting at desk.
Three squares (there is an opening at left side
of centre square). Cow. Bottle. The cap of
the bottle and the schoolboy's right foot are
enclosed in the right hand square.

TM12 (Reverse of TM11 is now facing, with the
reverse of TM10 visible below, etc. This
process continues up to TM16). Drawings
on a piece of tracing paper sellotaped in.
A lemon. Two dials with pointers, the right
one includes two arrow heads. Below two
similar circles with dotted lines and points.
Content (outside dial at top right) A ½A ½B
B (Dial at bottom left, inside) ¾C ½C ¼D ½D
(outside) C D. (Dial at bottom right, inside)
¾F ¼F ¼E ¾F ½E ½F grey. (outside) E F.

TM13 Drawings on a piece of tracing paper
sellotaped in. Hand holding a pistol.
Unidentifiable plant (?related to sunflower)
growing from ornamental vase.

TM14 Drawings on a piece of tracing paper
sellotaped in. 36 black dots of different
shapes and sizes, impinging on ten horizontal
parallel lines, which intersect a senile
grimacing head (from Leonardo).

TM15 Drawings on a piece of tracing paper sello-
taped in. Muscular torso with arms folded.
Large circle. Three five pointed stars of
different sizes.

TM16 Black biro scribbles. A square frame of clear
(unscribbled) rectangles spaced out as in a
dashed line. Then more biro scribbling so
that these rectangles — and with them the
square frame — are somewhat obscured.

TM17 Horizontal format. Five types of line run
across the page. They make detours, change
position, etc. A blank key has been partially
filled in in pencil and biro: **Content** (Line 3)
Two things going on at once. (Line 4) Violin.
(Line 5) Two things going on at once
(mechanical). Change in height could indicate
amplitude or pitch.

TM18 Writing in pencil. **Content** take a space/ make
a sound in it/ make another sound in it/
(ditto marks)/ (ditto marks)/ get to know
the space/ take an object/ do something to
it/ do something else to it/ (ditto marks)/
(ditto marks)/ get to know the object/ take
a person/ watch them make an action/ watch
them make another action/ (ditto marks) /
(ditto marks)/ get to know the person/ Do
something/ Do something else/ (ditto marks)/
(ditto marks)/ get to know yourself.

TM19 Horizontal format. The shape of a house has
been cut out and discarded. Then the whole

page, including the house-shaped portion showing through from the next page, is scribbled over in pencil.

TM20 Pencil scribbling in the shape of a house (see TM19) is surrounded by brick pattern in black ink.

TM21 Thirty pencil squares arranged in six rows of five, are separated by corridors half the side of a square wide. (side of a square equals one inch). Left, right, and bottom edges of the page provide sides of the outside squares. One corner of each square is marked off with an S— (or reverse S—)shaped curve in ink. Each of the 8 possibilities is represented between one and six times.

TM22 A cut-out rectangle of card is glued on. The rectangle has words in heavy black type printed on it. **Content** Reach your peak/ with a / pocket Poucher!

TM23 Six bold blobby (unidentifiable) characters in black ink.

TM24 Line drawing in lower part of the page of female limbs, mostly legs and feet with high heeled shoes. Also a jug.

TM25 Page covered with handwriting in three superposed directions: horizontal, vertical, diagonal (bottom left to top right). **Content** (illegible without superhuman powers of concentration).

TM26 Four systems of five widely spaced horizontal lines with punched discs of paper stuck on. The punched paper has small type on it, fragments of words. They seem to represent musical notes on the five-line systems.

TM27 A large silver-printed paper rectangle is glued onto the page. In the top part of the right margin are pencil scribbles emerging from underneath the silver. The scribbling is interrupted by four horizontal bands of white. Portions of ink drawing emerge in left, right and bottom margins from under the lower part of the silver. On the reverse: The portion of the ink drawing that is under the silver is inked in.

TM28 A rectangle is outlined by a dashed line in ink. In upper right of the rectangle is an image of an open mouth, transferred from newsprint by pencil rubbing.

TM29 Drawing in black ink. A wide-spaced five-line system is shown as wires with 23 birds on them in a variety of positions. On the reverse: two small scribbles in blue biro, by a child.

TM30 Groups of one to six stencil letters in blue biro. A few scribbles as on the reverse of TM29. **Content** (coded?) HYG IWSB MILZ/ DH QASTW/ OM JD FBU/ A RKYGIO/ PA JMDET U/ YS ZP BI/ GSEDQ VR F/ FAWWC J OO/ UT

TM31 Stencil letters of the same type as TM30 but jumbled up, with some in reverse. A square frame outlined in pencil in the middle of the page is left clean.

TM32 A diagram in black ink. Apparently a complicated arrangement of vertical and horizontal lines. The many features include small black rectangles, lines that end, V-shaped interruptions in lines. In fact the diagram represents elongated lettering, both vertical and horizontal. **Content** (horizontal) LOOK BEFORE YOU LEAP (vertical, from bottom to top) THE EARLY BIRD GETS THE WORM.

TM33 Scribbling in soft pencil. The scribbling is most dense in three horizontal bands.

TM34 Blue ink handwriting. A narrative (possibly

a dream relating to a Scratch event?) over three pages. **Content** The following evening at the Palace. In order to give the appearance of THE PRESENCE OF AN AUDIENCE the amorous gypsy has assembled all his friends and relations in alphabetical order along the gangways.

The BALD headed man receives his guests with gestures of defiance. They file in one by one while the tatooist and the cyclist whistle loudly in their ears.

They pull the most abnormal faces. SOME cheeks without bones. SOME Nose and chin but no mouth. Tongues too far out. All teeth and no lips. Cross eyes. SQUINTS. ETC:

The blacksmith is playing blind mans buff with ten little boys. He chuckles as they feel at his balls.

The gypsy and the cowboy are sawing up a table while the pregnant lady looks on counting her children to herself and smiling.

The intellectuals are searching for some-where to display their literary collection to advantage.

The private eye cautiously takes notes. When he notices the cripple is watching him, he blushes. The bearded LADY thinks.. oh good they're dancing again.. and turns out all the lights.

On the stairs there's a queue for the lavatory. The bishop's asleep in there. In his tipsy state he left the door open.

He's dreaming of holding a service for those lost on the dim church railway. Dungeness lighthouse looms large in his mind. His dream is shattered by a scream.

AT THE food counter
knives and FORKS.
one of them has got blood on.
The gypsy is adjusting his clothing. His tears serve to dampen the rags he's making by tearing up his shirt — for bandages? The private eye takes notes from a darkened corridor

The scarlet lady is blowing up balloons, she couldn't CARE LESS if they burst. The secretary is handing them out. with every BALLOON, a kiss. On her back is a plackard.

The old man and the blacksmith are telling Jokes.
The blacksmith roars with laughter and FALLS off his chair. Three little boys Help him to his feet. The old man bottles the jokes he hadn't heard before in an old cider flagon. He puts the FLAGON to his mouth and tells the joke
in one QUICK BREATH into the flagon and quickly corks it. He has a cellar of flagons full of jokes at home all maturing with age.
MUCH MERRIMENT
The cyclist is doing his exercises. Lying on his back his legs kicking WILDLY in the Air. The COWBOY is trying on some costumes. At LAST
He picks out the one he wants.
Well adorned
and ROYAL RED
not unlike the costume of a cinema commissionaire.

TM35 Two words handwritten in blue ink. **Content** (upper left) Lungs. (lower right) resting.

TM36 Ink outline of traffic arrow in circle pointing down diagonally to the left. Below right, a black cow (?with a white cow behind it). Surrounding like flies are words based on MOO (give or take a few M's and O's); also SSHL (at the cow's arse).

TM37 Handwriting in black ink at top. Below, two adjacent sides of a square in black ink, and in the square a rubbing of a mouth and nose from newsprint. On the reverse: offprint of a coloured image of (?) children participating in a demonstration. **Content** do something till you go wrong./ when you go wrong, sing a long note and then resume.

TM38 Handwriting in blue ink at top. Below, a
rectangle outlined in black ink enclosing
large black stencil letters. Dimensions of the
rectangle are given in blue ink: 4'6" high by
5' wide. **Content** (handwriting) Some stones.
(2 or more)/ about the size of a child's fist./ or
2 or 3 sizes bigger. (stencil) HELP TO/ KEEP
TIME

John Nash All words are in neat italic handwriting

JN1 **Content** Think of any simple tune, such as a
child's nursery tune, and hum it quietly
backwards, take as much time as you need,
and then some. (Pause whenever you like)

JN2 **Content** Moan quietly and sadly, mouth
open.

JN3 Zigzag line interrupted twice by large black
dots.

JN4 Horizontal line with three slight swellings
above, drawn in light pencil.

JN5 Strong pencil horizontal line rising three
times to wave-crests and falling back.

JN6 Groups of black dots arranged horizontally
as follows: 1 2 1 5 (clustered) 1 3 1 2.

JN7 **Content** Play violin upside down.

JN8 **Content** Play *Lamento di Tristan* softly
and repeatedly.

JN9 **Content** *Sumer is icumen in,* ditto.

JN10 **Content** with mouth either open or closed,
hum as much as you can remember of a
piece you particularly enjoy, especially if it

is totally impossible to hum. If you would
like to hum it again, do so until you are tired
of it, and then go on to another, listening to
your neighbor meanwhile.

JN11 **Content** Hogamus hygamus / Man is
polygamous / Hygamus hogamus / Woman
monogamous /. Thinking of the above poem
as a series of attractive-sounding syllables,
choose a single note and sing the poem
through on that note, syllable by syllable,
one breath to a syllable. If, on completing
the first round, you feel displeased with
the note you have chosen, try another.

JN12 The words to be contemplated are displayed
in large capitals, one word to a line, centred.
Content Contemplate the following words
FIRST/and/ LAST/PERFORMANCE/
ANY/WHERE/ then play.

JN13 A paragraph from an article by Buckminster
Fuller is struck down, and the centre section
of a small colour photo of John Cage's
laughing face is struck in the middle of it. At
right are drawn two vertical lines, angled
slightly to form an elongated X; they are
marked A and B. A line copying the ragged
ends of the paragraph of type intersects this
figure like a temperature graph. Eleven bold
horizontal bars are spaced unequally down
the left side of the figure, and nine bold dots
are spaced unequally down the left side. The
fourth from the top has a zero in brackets
to its right.

JN14 **Content** (from Jung) Everyone take a piece
of paper and pencil, draw a picture or design
(whatever comes into his head), exchange
drawings with the third person away from
him and interpret that drawing for a certain
amount of time before going into piece which
has been chosen beforehand to play. (On the
reverse of JN14) Each participant provides
himself with a heap of pictorial magazines
(the more outdated the better) and reads the
advertisements aloud, varying pitch and in-
tonation according to the size of the letters

and the content of the words. He may sing if and when he likes. If a particular advertisement pleases him particularly, he may stop and read it backwards.

JN15 **Content** (from Turning On, by R Gustaitis) Tune a brook by moving the stones in it.

JN16 **Content** Kazoo chorus. Read a long and boring poem aloud, kazoo in mouth. (For example, the Song of Hiawatha.) Solo: Excitement, disgust, protest, kazoo in mouth.

JN17 **Content** Fill a container with water. Place three or four pebbles in it. Play music over the surface of the water, attempting to make it boil, and turn to tea. (Mother: Edward Lear)

JN18 16/7/69 A round-cornered rectangle cut from a colour magazine shows six small portraits of prominent 20th century figures. Top row: Chamberlain, Ho Chi Minh, DH Lawrence. Bottom row: Hitler, Keaton, Eisenstein. Below these another small portrait (?Count Basie).

JN19 LATER THAT EVENING 16/7/69; 18/7/69. One picture from a picture story. Two girls are speaking to each other. The words of one are obliterated by a small portrait of Trotsky, the words of the other by a small portrait of Beria. **Content** Later that evening in Joan's flat. Pat is still overwrought.

JN20 WRITER 17/7/69 Large colour photo portrait of Isaac Babel.

JN21 17/7/69 Small portrait collage. The left side of the face is Louis Armstrong, the right side Winston Churchill.

JN22 LOW DOG 18/7/69. A portrait of a Red Indian in ceremonial dress. Over his nose and mouth and chin a small colour portrait of Marlene Dietrich. At bottom left a small oval portrait of Shirley Temple saying 'ooh'.

JN23 18/7/69 Neatly scissored profile of Savonarola. Colour reproduction of an oil painting.

JN24 EXPLORER 18/7/69 Large black and white portrait of an explorer (?Amundsen). The same portrait but small and in colour is cut in an oval and stuck on the large portrait in the region of the left temple.

JN25 19/7/69 A small colour portrait of G B Shaw is stuck in the opening of a John Cage T-shirt.

JN26 TODAY HE MISSED HIS MILK 19/7/69 A large round black and white portrait of Buckminster Fuller with bold type stuck down above and below it. Emerging from behind the lower piece of newsprint and overlapping the round portrait is a small colour portrait of Pierre Boulez. **Content** (top) Today / he missed / his Milk. (Bottom) Again.

JN27 ROSE 20/7/69 Colour printed illustration of a rose. Stuck over it a small colour portrait of a pink hatted lady. **Content** Josephine Bruce

JN28 ROSE 22/7/69 Similar picture of a rose. Stuck over it a small oval colour portrait of Ezra Pound. **Content** Ena Harkness

JN29 ROSE 22/7/69 Similar picture of a rose. Stuck over it a small colour portrait (?Caruso). **Content** Eden Rose

JN30 ROSE 22/7/69 Similar picture of a rose. Stuck over it a small colour portrait of the Duchess of Windsor. **Content** Pink Sensation.

JN31 Illustration cut from a magazine. **Content** Beethoven's ear trumpets.

JN32 Portrait (Yoko Ono as a child) and caption cut from a magazine (family album style presentation). Below this two words in large type cut from a magazine. **Content** (caption) Born: 'Bird Year', in Tokyo, to the former President of the Bank of Tokyo. 'Early childhood: collected skies. Adolescence: collected seaweed. Late adolescence: gave birth to a grapefruit.' Wrote Japanese Haiku poetry when four years old. Has made film of St. Isidore's

Thigh Bone. (Separate clipping) misunderstood bed

JN33 Colour photograph of a man with a gun. Scarely legible type is printed at an angle over the gunsmoke. **Content** SCREEN/ GANGSTER/ Delon.

JN34 Small colour portrait of Mao Tsetung.

JN35 Small colour portrait of Alexander Blok.

JN36 Small colour portrait of Picasso

JN37 Small colour portrait of Hemingway

JN38 Small colour portrait of a man with handlebar moustache

JN39 Three small colour portraits — Dizzy Gillespie, Eichman, Mary Pickford. The two outer portraits overlap the centre one so that only a bespectacled eye and a smile crease are visible.

JN40 Small colour portrait of Rasputin

JN41 Large colour portrait of Aleister Crowley.

JN42 Large colour portrait of Dr Crippen. The print looks like a coloured Xerox.

JN43 In a red and blue circular border, portrait of a young man with three Chinese characters on each side of his head. **Content** Chiang Kai Shek

JN44 Tinted photo of a man looking West. On the right a beautiful copperplate scrawl from bottom to top. **Content** Al carissimo amico / Giuseppe Bazzi / Sentitamente affie / Enrico Caruso / . . .vitra 1902

JN45 Three small portraits one above the other, the centre one in black and white (?,?political assassin, ?inventer of the biro).

JN46 Small colour portrait of Beria

JN47 Under the heading the content is arranged in five columns. In the first, the Chinese words and their translation with trigram (first two items) or hexagram (the remaining three items) below. In the second, circular symbols: first a black circle with a bite out of the bottom; second, a white circle with a black bite out of the bottom; third, a circle with a black dot in the centre; fourth, a white circle; fifth a black circle. The third and fifth columns are written normally, the fourth is written vertically from the bottom up. **Content** (heading) Ch'an Buddhism: Ts'ao Tung (soto) symbols. (Column 1) 'Sun' (wind), 'Tui' (damage), 'Ta Kuo' (greatness), 'Chung Fu' (faith), 'Chung Li' (illumination). (Column 3) The real containing the seeming, The seeming containing the real, Resurgence of of the real, The seeming uniting with the real, Integration of real and seeming. (Column 4 starting at the bottom) absolute collective achievement, submission, shift. (Column 5) Host position, Guest position, Host coming to light, Guest returning to host, Host in host.

JN48 **Content** Scratch Music. Take any rough or interesting surface, including your own or someone else's, and scratch it. Use a variety of implements. Do not scratch anyone who does not want to be scratched; do not draw blood; be gentle at all times, and listen carefully.

JN49 **Content** Thoreau: Be as melancholy as you can be, and note the result (Journals). Be ever so little distracted, your thoughts so little confused, your engagements so few, your attention so free, your existence so mundane, that in all places and in all hours you can hear the sound of crickets in those seasons when they are to be heard.

JN50 Page 198 from Wheeler's Review 4th Qtr. 1968. The copy is placed inside a thick black border. **Content** CRIME AND BANDITRY, / DISTRESS OF NATIONS, / & PERPLEXITY / will increase until the Bishops open / Joanna Southcott's / BOX OF SEALED WRITINGS / What the Bible says about the Box / and the Bishops: / "And the temple of God was opened . . . and / there was seen . . . the Ark (Chest or Box) of his /

Testament (or Will)." / "And round about the Throne were four-and /-twenty . . . Elders (Bishops) sitting . . . (and they) / fall down . . . and cast their crowns (their / wisdom) before the Throne". / Rev. xi 19; iv 4, 10 / THE PANACEA SOCIETY / BEDFORD, ENGLAND. (On the reverse — p 197 — a few hundred words of a report on Italian food).

JN51 Clipped from a magazine and pasted in, a black and white photo of a Red Indian. **Content** Short Bull (Sioux)

JN52 Another Red Indian, similarly treated, **Content** Kicking Bear (Sioux)

JN53 Another. **Content** Sharp Nose (Arapaho tribe)

JN54 Another. **Content** Rain in the Face (Sioux)

JN55 Another. **Content** Wolf Robe (Cheyenne)

Michael Parsons (the composer's selection. Original numbers are given in brackets. Dates indicate when the pieces were used).

MP1 **Content** (3) Instrumental. Play one note, repeatedly. On playing another note, by mistake, repeat it — use it in addition to the first note. Continue playing these two notes until you play another, by mistake. Each mistake is incorporated into a gradually increasing ambit of notes. 16 May. When you have as many notes as you can manage, start eliminating them one by one.

MP2 **Content** (4) Saxophone, with reed made from cigarette packet/ playing card etc. Lowest sound possible, as soft as possible. Repeat as many times as possible in each breath. 17 may 20 may 9 junc. (4a) using reed made from card, follow instructions for accompaniment (3). (4b) using reed made from metal sheet, follow instructions for accompaniment (3).

MP3 **Content** (7) Drawing chalk circles on floor. 22 May.

MP4 **Content** (8) Picking things up from floor. 27 June. Think of other ways of using the floor: sweeping it, measuring it, lying down on it. Enter a description of each thing picked up in a notebook. Keep all the things in a bag. 19 Sept.

MP5 **Content** (10) Taping-Tape up cracks and openings with stick tape. 15 June 69

MP6 **Content** (12) Nailing pieces of wood together. 29 May. Needed: Several pieces of wood, a hammer, a lot of nails. Nail the pieces together. (NB. pay attention to the nailing, not to the sounds.)

MP7 **Content** (13) Writing. 29 April 69

MP8 **Content** (14) Walking. 2 August 69

MP9 **Content** (15) Saxophone: (music notation of six notes rising from 4th line of treble clef: d, e, f-sharp, g, a-flat, e-flat). 10 August 69

MP10 **Content** (21) Choose one other player and follow his or her performance closely. Play only when he/she is not playing. 9.10.69 (21a) Choose one other player, and, treating his/her playing as if it were a solo, accompany it. (21b) Choose two other players to follow. When both are playing, listen. When one of them stops playing, accompany the other. When both are not playing, don't play either. 11.10.69 (21c) Similarly, with 3, 4 or more players.

MP11 **Content** (25) Window Music. Wet one or more fingers, and draw them across a

window pane, pressing hard/soft; Different kinds of movement give different sounds: eg — Straight lines — one way; backwards and forwards: /horizontal:/ vertical:/ diagonal:/ circular motion:/ figure of 8: etc. .9.1.70 (25a) May be done on other shiny surfaces — eg. polished wood/ gloss painted surfaces/ some plastic materials.

MP12 **Content** (26) Table Music. 18.11.69 Make as many different sounds as possible with a table: eg. rhythmic drumming with hands and fingers/ rubbing with fingers (dry or wet)/ scraping, drawing across floor (as in Poem)/ scratching with fingernail.

MP13 **Content** (27) Rattles 26.1.70 Different kinds of rattle: tins/wooden boxes/ cardboard boxes/ matchboxes/ glass bottles and jars/ gourds/ plastic containers. Pins/ screws/ seeds (lentils barley rice etc)/ matches/ sticks/ stones/ buttons. (27a) tambourine

MP14 **Content** (28) Rope 10.1.70 Knots: Round turn and two half hitches: (diagram) under, over and through times two. Bowline = (diagram). Clove hitch: (diagram) then put right hand loop on top of left hand loop.

MP15 **Content** (29) Scratch Music for violin 4.12.70 trills/ glissandi/ occasional pizz./ (and tremoli)

MP16 **Content** (30) 5.12.70 gradual transitions

MP17 **Content** (31) 6.12.70 Sweeping/ (see also no. 8 (MP4) for a particular case)

Tom Phillips

TP1 Small square extract from IRMA glued on, encircled by red ink line. Sequence of 14 red ink dots leading to red ink self portrait of Tom Phillips. Three more red ink dots leading to bubble containing red ink writing. The IRMA extract is maybe 1½ x 1½ inches. The printed text is obscured by parallel vertical lines. **Content** ume her writing. Sh / ny formal break; but I / resently scratched the / iterary form or consis / , and slowly, but w / ew lines, which might / (line space, followed by indentation) All these papers / h; it is very pretty. (In lines 3, 4, 5 the words "scratch" "form" "slowly" are circumscribed and left unobscured by vertical lines. In lines 6 & 7 the word "lines", and the "A" of All are similarly circumscribed and left unobscured.) (Red ink writing) thinks. well if that isn't Scratch music what the hell is?

TP2 POSTCARD COMPOSITIONS (OP XI) **Content** BUY A POSTCARD. ASSUME THAT IT DEPICTS THE PERFORMANCE OF A PIECE. DEDUCE THE RULES OF THE PIECE. PERFORM IT.

TP3 Op XI No. 1 **Content** Buy two postcards. Assume they depict performances of the same piece. Deduce the rules of the piece. Perform it.

TP4-11 are specimens of TP2

TP4 Postcard. Sepia photograph of tea-table set for three. In the centre a dish of 5 Cornish pasties. **Caption** ZET DOWN AN' 'AVE A TATIE PASTY AN' 'A DISH 'A TAY. 1076. On the reverse side: postmark on a half penny stamp "PLYMOUTH 11.15 PM AU 20. 08" **Content** (Printed) POST CARD 50 G For Communication only this space may be used. For Address on (Handwritten) Dear Leslie Just a p.C. to wish you "a happy birthday Love from Elsie. Master Rattenbury 36 Chaddlewood Avenue Plymouth.

TP5 Postcard. Hand-Coloured (?) Photograph of a large rock resting on a small lump on the moors. **Caption** (in brown type) THE IDOL ROCK, NEAR RIPON, YORKSHIRE. (bottom right corner, almost indistinguishable) Copyright. On the reverse side: largely indecipherable postmark over half penny stamp "WA . . . AU 10. 06" **Content** (printed) POST (then, inside a six-pointed star) GD & DL CARD. COMMUNICATION HERE. INLAND ONLY. ADDRESS HERE. (Handwritten) North Common, Aug 10th. Just a line to thank you for returning my blouse. I returned from Wells yesterday. I am enjoying myself proper. Haveing nice weather. I suppose Mrs C. have gone before now I hope you are all well dont work to hard love to all. M.A.C. Miss Prust, The Palace, Gloucester.

TP6 Postcard. Colour photograph of a London Policeman No. G 272 in front of a London Bus No. KGK 514. Between the two a blurred man is crossing the road. **Caption** (black italic type) A London Policeman on duty. On the reverse side: various black solid and dotted lines and a rampant ?dragon to show where the stamp should be affixed. **Content** A London Policeman on Duty LD24. Young's Photo Reproductions, London W.9. TEL 286, 5382 KODAK EKTA-CHROME FILM BRITISH PHOTOGRAPHY PRINTED IN ITALY.

TP7 Card about the size of a postcard. To the left a half-tone drawing of a smartly dressed man with a hat, holding a cane and a cigarette in gloved hands. **Content** FRED SQUIER, FOR TAILOR-MADE FLANNEL SUITS, COOL AND COMFORTABLE. FAULTLESSLY CUT AND FASHIONED. Immense Stock to Select from. 8/11 to 45/-.

TP8 Card, the reverse of TP7. Black and White of 4 swans and 4 men and a ?lady seated on a bench in an ornamental park. **Caption at bottom** THE CASTLE PARK, COLCHESTER

IXL series.

TP9 Postcard. Colour photograph of a band playing on a bandstand in a park. The bandstand is seen to the right over the heads of the audience which is sitting in rows of collapsible chairs. One section of the audience appears to be dwarfs. Several members of the audience appear to be sitting in 2 seats at once. An avenue between leafty trees leads away to the left hand side. On the reverse an arrangement of a dotted rectangle, 2 dotted horizontal lines, a bold horizontal line and a further dotted horizontal line shows where a stamp is to be affixed and the address written. **Content** (vertically up the centre) Farbkarte Nr. 745 — Photo-Verlag Wilh. Müller, Asslar/ Wetzlar (in two lines at top left) Luftkurort Braunfels/Lahn. Kurkonzert im Schlosspark.

TP10 Postcard. Black and white photo of a no-entry street with church tower in the background. Foster's Corner is in the right. **Caption at bottom** WVN. 1. WOLVERHAMPTON. DUDLEY STREET. (on the reverse side in grey type) POST (then, surrounding a 12-pointed star with a cow's head inside it) MASON'S ALPHA SERIES / PRINTED IN ENGLAND. CARD / GREETINGS AND BEST WISHES / (vertical from bottom to top, centred) Copyright Real Photograph.

TP11 Postcard with irregular beveled edge. Colour photo of a shingle beach, breakwaters and in the background hotels and white cliffs. A cloudy blue sky. People are picknicking, swimming, standing about. A 'beveled' line ends the photo about ¼ inch above the bottom of the card. In the white space thus obtained, the following **caption**: The Beach, Saltdean. ET. 4724. On the reverse side various lines, dots and symbols printed in grey. **Content** V by Valentine PRINTERS AND PUBLISHERS, DUNDEE AND

TP12-39 are specimens of TP3 using the materials
TP4-11

TP12 Juxtaposition of the two postcards TP4 & TP5

TP13 Juxtaposition of the two postcards TP4 & TP6

TP13 Juxtaposition of the two postcards TP4 & TP7

TP15 Juxtaposition of the two postcards TP4 & TP8

TP16 Juxtaposition of the two postcards TP4 & TP9

TP17 Juxtaposition of the two postcards TP4 & TP10

TP18 Juxtaposition of the two postcards TP4 & TP11

TP19 Juxtaposition of the two postcards TP5 & TP6

TP20 Juxtaposition of the two postcards TP5 & TP7

TP21 Juxtaposition of the two postcards TP5 & TP8

TP22 Juxtaposition of the two postcards TP5 & TP9

TP23 Juxtaposition of the two postcards TP5 & TP10

TP24 Juxtaposition of the two postcards TP5 & TP11

TP25 Juxtaposition of the two postcards TP6 & TP7

TP26 Juxtaposition of the two postcards TP6 & TP8

TP27 Juxtaposition of the two postcards TP6 & TP9

TP28 Juxtaposition of the two postcards TP6 & TP10

TP29 Juxtaposition of the two postcards TP6 & TP11

TP30 Integral view of the card TP7/8

TP31 Juxtapisition of the two postcards TP7 & TP9

TP32 Juxtaposition of the two postcards TP7 & TP10

TP33 Juxtaposition of the two postcards TP7 & TP11

TP34 JUxtaposition of the two postcards TP8 & TP9

TP35 Juxtaposition of the two postcards TP8 & TP10

TP36 Juxtaposition of the two postcards TP8 & TP11

TP37 Juxtaposition of the two postcards TP9 & TP10

TP38 Juxtaposition of the two postcards TP9 & TP11

TP39 Juxtaposition of the two postcards TP10 & TP11

Howard Skempton

Howard Skempton's Scratch Music is presented as in
the following example: (code) HS1, (content) ICE-
BERG, (date) 110669, (coordinates) (x equals) 4.
(y equals) 7. The items of Scratch Music occur on
a grid measuring 18 centimetres along the x-axis and
23 centimetres up the y-axis. The values given after
the date show the (approximate) position on the
page of each piece of Scratch Music. In the Scratch-
book several pieces appear on each page. After the
last item on a page the word 'turn' is inserted after
the coordinates.

The interpretation of the position of an item of
Scratch Music on the grid is described by Howard
Skempton as follows:

frequency (y). average duration of sounds (x).
Change of page = change of medium. The chosen
accompaniment becomes the mean (frequency, etc).
ie, with the accompaniment, for example in the
bottom left-hand corner (1.1), most of the sounds
are high and long.

HS1 ICEBERG 110669 4.7

HS2 PERIODIC / APERIODIC 140669 14.23

HS3 FRICTION - DRUMSTICK, CYMBAL
 150669 7.14

HS4 DANGEROUS RELATIONSHIPS 170669
 2.22

HS5 OLD POPULAR SONGS 180669 8.12

HS6 BELL SOUND 190669 14.3 (turn)

HS7 MISTY MIRTH 220669 1.9

HS8 HUM EROTIC 240669 14.18

HS9 LOOP SPEECH 250669 13.14

HS10 TWO THINGS AT ONCE 260669 3.14

HS11 DREAM 290669 15.2 (turn)

HS12	PORTRAIT OF AN ABSENT PERSON 010769 11.23
HS13	COLD WATER 020769 7.4
HS14	TANGLE WOOD 030769 12.13
HS15	UNDULATION THROUGH MOONLIGHT 050769 2.11
HS16	LAPSE 070769 6.17
HS17	WORKING WITH WIRES 080769 11.9 (turn)
HS18	EIGHTEEN 090769 14.10
HS19	FRUSTRATE ANTICIPATION 100769 11.12
HS20	DRONE 110769 1.18
HS21	LIFEBOAT DRILL 120769 13.22
HS22	WITH HASTE 130769 1.9
HS23	WATER RHYTHM 140769 12.5
HS24	ILLUSION 210669 6.6 (turn)
HS25	GENERATE 150769 1.18
HS26	MELODIC VARIATION 160769 4.13
HS27	DRIVE SLOWLY 170769 12.16
HS28	THE GREAT INVENTOR 180769 7.8
HS29	BACKLASH ETC. 190769 9.7
HS30	ORNAMENTS 200769 5.6 (turn)
HS31	REFRESHMENT 300769 7.2
HS32	INDIGENOUS MATERIAL 030869 1.12
HS33	DISCREET DISPOSAL 080869 2.21
HS34	S→R R→S S→R S→S 120869 8.13*
HS35	CONTEMPT OF DEATH 140869 7.9
HS36	ROUGH/SMOOTH 180869 8.14 (turn)
HS37	APERIENT 190869 1.15
HS38	UNWRAP SLOWLY 200869 11.14
HS39	MINOR MUSIC 210869 8.12
HS40	FOUR DOWN 220869 12.9
HS41	FOUR-FORE (FINGER EXERCISES) 230869 2.7
HS42	SOUND ASSOCIATION 240869 7.23 (turn)
HS43	TRANSFER OF TRAINING 250869 8.15
HS44	LIKE AN INVERTEBRATE 260869 13.11
HS45	BRAIN-STORMING 280869 1.7
HS46	TWO THOUSAND PINS 290869 5.4
HS47	HIGH SOUNDS IN GROUPS 300869 3.3
HS48	DEEP DOWN 010969 16.21 (turn)
HS49	RECORDING 030969 7.13
HS50	EXTENSIONS 170969 2.22
HS51	WHERE THE MOUNTAIN MEETS THE SEA 230969 7.5
HS52	AN UNCOMMON OBJECT 270969 1.7
HS53	SIMPLE IMITATION OF PASSING SOUNDS 280969 5.7
HS54	TRANSLATE 011069 15.16 (turn)
HS55	TRAINING A DOG 081069 5.16
HS56	BROKEN PROJECTOR LAMP 111069 1.4
HS57	STRING SONG 121069 2.11
HS58	FUSE 131069 15.17
HS59	WAVES 181069 14.20
HS60	COLLECTING 271069 11.14 (turn)
HS61	ONE PLAYER 281069 7.13
HS62	ONE STONE 021169 15.9
HS63	QUIETLY 231169 3.6
HS64	FINGER ROLL 301169 3.19

*S = stimulus, R = response

Catherine Williams

Graphic material not specifically described as Scratch Music

CW1 Three pages of drawing in blue ink with shades of gold on white paper. **Content** (integrated lettering) SPINSPINSPINSP etc. (Lettering along the bottom) 3000 PEOPLE SPIN — OR ANY NUMBER — SPIN ROUND AT A COMFORTABLE SPEED UNTIL IT IS NECESSARY TO STOP — STOP UNTIL ABLE TO START AGAIN — REPEAT A PREVIOUSLY SPECIFIED, AGREED, I MEAN, NUMBER OF TIMES

CW2 Swirling drawing in blue ink and many colours and gold. **Content** (integrated lettering) SPINSPINSP (etc.). 3000 PEOPLE SPIN 3000 PEOPLE SPIN 3000 (etc.).

CW3 Drawing in blue ink and silver. **Content** (integrated lettering) PSUEDOPODIA PSUEDOPODIAPSUEDO (etc). (Instructions) For any number of people One shall lead and walk to a spot chosen by him or herself and sit down followed by the rest falling into a flowing line behind shall sit down in the chosen area as each one arrives at it grouped around the leader in silence rest head on knees lie down for an indefinite period until the leader again decides to rise and make off whither he or she will shall all follow rising one at a time roughly speaking and flow into a following line moving quietly through the air he or she sits once more nucleate whilst arriving settling everyone else unobtrusively gets there and subsiding once more rests the air rests breath until the leader again decides to rise and go with decision here or there it may be like a migrating bird and all shall follow silently. . .

CW4 Silver circles of various sizes with integrated lettering in blue ink. **Content** — AT SPEED COLD ROUND SURFACES SHOULDER

ONE ANOTHER AT SPEED — WHIRLING FAST UNTIL THEY ARE SLEEK AND GREY — DRIVING LIKE MILLSTONES — HUGENESS SET SPINNING — HANGING—

CW5 Circles and related shapes, silver changing to gold. Lettering in blue ink. **Content** SILVER INTO GOLD. 10 minutes 1. 10 minutes 2. 10 minutes 3. 1. short sounds cold clipt repetitive chattering clattering percussive ragged crystal broken glass edge harsh jagged spasmodic abrupt ice crashing mutter disparate knocking clicking avoid wind instruments no long sounds. 2. mingle and warm the percussiveness of 1. with sounds from 3. begin to explore tone and pitch gradually introduce wind sounds. 3. lengthen sounds abandon harshness soften intensify ripple pulse melody liquify swathe rustle attenuate swish sweeten soar burn mysticise elevate fly harmonise complete the metamorphosis bind concentrate purify. As many players as possible. To last half an hour, or any evenly balanced length of time (ie. which can be divided into equal thirds).

CW6 Outline of a hand with blue ink lettering. **Content** HANDS. Get to know your own hands, their texture, consistency, capacity, their potential. Get to know other people's hands, largely by means of your own — in comparison with your own. Let them be witty, kind, strong, capable, avenging etc. . . together or apart. Similar proceedure for FEET, EARS, HEAD, PARTS OF FACE, FACE, BACK, FRONT — of BODY —and so on

CW7 Circular design in blue ink and silver and many colours. **Content** HEAD ROLLING RITE. . . . Sit cross legged think breath contemplate breath look out. . . wards . . . relax neck incline head roll to this side . . . to that side . . . let it go pause gaze gaze . . . move pause . . . be dazzled drift over and back round and back . . . stretch . . . your neck round we go rock lull loll sun

or light bulbs in candescence . . . (Hugh shall play meanwhile, toy piano music. Optional and rather depending on Hugh).

CW8 Circular design in silver and gold radiating blue ink letters. **Content** METAMORPHOSISMETAMOR (etc)

CW9 Circles in shades of gold and silver radiating blue ink lines. **Content** (integrated lettering) GOLDGOLDGO (etc) DOLPHINCHANGE DOLPH (etc) METAMORPHOSISMETA (etc) SILVERSILVERSIL (etc) DOLPHIN SILVERDOLPHINSIL (etc)

CW10 Fragmented design in blue ink with gold and silver. **Content** BUILD DLIUB Empty central space necessary. Sit in a circle surrounding the space. Tend to have a collection of usable materials/instruments by you — one person at a time beginning with anyone, place one object in the centre — re-sit (-or sight any object in the room — get it, place it, re-sit). ie. Proceed to BUILD in turn. Place an object, or adjust the pile if it displeases you. One 'object' per trip. When it seems everyone has had a turn — get up when someone else does. Two simultaneously BUILD. Accumulate in numbers until all BUILD at once. Fetch several objects at once. Circle will be broken up — no need to reconstitute it after each trip. UNBUILD (DLIUB) when the situation begins to get out of hand or source of objects runs out. Take back what you put on the pile / your own possessions — return other people's possessions to them. Reconstitute the circle — sit down, when you think you done enough. If you don't want to BUILD, PLAY. If in the original circle, make it clear you are playing and not BUILDING. Alternate if you wish. If there is an audience suggest it should help to BUILD also. At a certain point BUILDing and UN-BUILDING may be interacting as two simultaneous forces. Let it be so, whichever aspect you are interested in. Rite ends when the BUILT in space is once more empty.

CW11 Wavy design in shades of blue, silver and shades of gold. Integrated lettering in blue ink. **Content** MUSIC I NESTLE AND REST MY FOOTSTEPS ON YOUR PLATFORM MUSIC ON YOUR SWAYING BRANCH MUSIC MY HANDS TAKE YOUR THREADS MUSIC WRAP TIGHT OVER OVER OVER MUSIC MY HEART RESTS DEEPER MY NERVES CLUSTER AND TWINE MUSIC SHALL WE DANCE ALL OF US WITH YOU HERE I AM HERE WE TAKE HANDS HAND DANCE FEET SLIP SWING DEAR KIND MUSIC LET ME DANCE IN YOUR STRONG ARM MY SKIRT SWAYS THE MEASURE IS LONG MUSIC I NESTLE AND REST MY FOOT (etc)

CW12 Design of three circles quartered in gold and silver overlapping with connecting lines and integrated lettering in blue ink. **Content** THEN/NOW. HISTORY NOW IS THEN IN YEATS' GYRE HISTORY NOW (etc). FURLING AND UNFURLING ROLLS THE GYRE OF COSMIC EXISTENCE FURLING AND (etc). DIMINISHING AT THE SAME TIME IT FLARES AND . . .

1001 ACTIVITIES

1001 Activities, by members of the Scratch Orchestra

1 Draw a picture of a cat
2 Puff of smoke
3 Tap dance
4 Impression of Marlon Brando
5 Rotate your boat before commencing
6 Don't play music from Fiddler on the Roof, (alternatively do)
7 Remember all the activities you've done
8 Impression of chalky the white faced golliwog
9 Realise that Neptune is in conjunction (perhaps inform some people)
10 Activity that you will perform in the future
11 Sit down, stand up and say 'is there anybody here' (6 times)
12 Take the three balls from a pawnbroker's shop and roll them around the lawns at Buck House.
13 Break window of old school
14 Listen to the birdies (on one leg)
15 Change hats
16 Ride a cock horse to Bambury Cross
17 Go tell it on the mountain
18 Do the hokey cokey
19 Tell a child a story
20 Shake that thing
21 Read extract of prose upside-down (the prose)
22 Sacrifice a brown paper bag (sheep's bladder)
23 Impression of a Turkish soldier
24 Insist on a game of ring-a-ring-a-roses
25 Turn over a new leaf
26 Hand on belly – Barber of Seville
27 Do brass rubbing (not necessarily brass)
28 Addition: 27395 + 750026 + 43 + 4310763 + 891540718 + 92
29 Note the position of all slippery merchants
30 Impression of Dr Cameron
31 Visit inner ear ⁻
32 Visit stomach
33 Visit heart
34 Look at the river
35 Minutes silence (with salute) for John Denison CBE
36 Imagine you're at a concert starring Judy Garland
37 Steal a bell
38 Song 'She's only a bird in a guilded cage'
39 Something with liquid
40 Alter hair style
41 Travel a short distance on knees (holding feet)
42 Brush yourself off
43 Funny laugh

44 Funny laugh plus silly walk
45 Funny laugh plus silly walk plus comical facial expression
46 Funny laugh plus silly walk plus comical facial expression plus something sadistic
47 Play elastic band
48 Form elastic band
49 Knit
50 Make necessity a virtue
51 If not engaged in anything else, look for wars
52 Look askance
53 Try just a little bit harder
54 Walk on heels once round Queen Elizabeth Hall
55 Flip, flop, flip, flop
56 Imitate as closely as possible someone else's playing
57 While away a period of time
58 Inspect socks for holes (as many pairs as possible)
59 Rip of a button
60 Comb hair, ruffle it, comb it, ruffle it, comb it. . .
61 Do any activity backwards
62 Wipe the smile off someone's face
63 Urinate
64 Go higher and higher
65 Find yourself through a maze
66 Sing the blues
67 Watch something grow
68 Frown at something funny
69 Smile at something sad
70 Speak unintelligibly
71 Throw many things far and wide
72 Dance
73 In these accents — South American drawls, African, Australian, Welsh (high pitch), Welsh (low pitch), English, Yorkshire, Bolton — (say text of no 73)
74 Count your chickens before they hatch
75 Kick
76 Short Shakespearean recitation
77 Fidget
78 What's 78?
79 Insult someone
80 Flick
81 Answer telephone
82 Drive a 32 ton articulated lorry
83 Mend watch
84 Ask a policemar
85 Eat a cherry
86 Make them come thick and fast

87 Become a cavalier
88 Have an after 8
89 Switch on your colour TV
90 Look like a ponce
91 Tread in puddle
92 Established 1830
93 Play music box
94 Bite your nails down to your elbows
95 Let your shadow follow you, give it a few words of encouragement
96 Revolve
97 Look bored in back of taxi
98 Prepare to undergo random method of your choice to decide when to eat a sandwich
99 Write to Marjorie Proops for advice
100 Expose yourself
101 Take a selection from what you get
102 Swear
103 Avoid a Corsican
104 Get into Boys and Girls exhibition without paying
105 Punch your best friend on nose
106 Sew button on
107 Delete a right angle
108 Hang on
109 Wince with disillusionment
110 Behave like Nixon
111 Fire one of your employees
112 Point in same direction
113 Warn cloakroom attendant
114 Demolish your home
115 Destroy something
116 Put your hands between your legs, up your back and cover your ears with them
117 Hide
118 Surreptitiously enter sleazy joint
119 Do all actions necessary to play / sing a piece of music
120 Fill a tank
121 Slide down a moonbeam
122 Flash nice crisp greenie
123 Tear a five pound note in 3 pieces
124 Toss in the air
125 Count up to 167
126 Follow dotted line
127 Do the last thing you forgot
128 Undergo labour pains
129 Make a decision
130 Play without rhyme or reason
131 Imitate a drunken Italian

132 Inquire of the wife's whereabouts
133 Use gold dice to decide whether or not to inform your client that he has to appear in court on Tuesday
134 Cut a tomato into 62½ pieces — distribute
135 Investigate an extraterrestrial activity
136 Half time: suck a lemon
137 Say it with flowers
138 Defrost chicken
139 Soak overnight
140 Abuse yourself
141 Amuse yourself
142 Bind and reap
143 Divest yourself of an ornament
144 Expertly weigh 12" cigar in left hand
145 Vamp
146 Take lid off petrol can
147 Blush at a compliment
148 Blanch at a vulgarity
149 Smoke a cigarette
150 Place cigarette on back of drivers hand in order to make point
151 Dismiss your concubine
152 Swallow your words
153 You must laugh
154 Celebrate the arrival of 154
155 Dismiss all evidence
156 Sing a rude song
157 Write love letter to the DJ of your choice
158 Become hyper-conscious of breathing
159 Blow the wind southerly
160 Dissuade a newcomer to eat fois de gras
161 Sweep the floor
162 Mark out an area and never walk in it again
163 Dig the progressive blues in the evening sky
164 Get your gums around my plums
165 Tiptoe through the tulips
166 Run off
167 Have a pint
168 Have a Sarni
169 Tread lightly up the apples and pears
170 Hang off top of double decker bus
171 Get your gums around my plums
172 Tiptoe through the tulips
173 Don't get your knickers all twist
174 Keep the pot boiling all the way down to Cornwall
175 Tan your arse
176 Mind your manners
177 Don't call us, we'll call you

178 Negotiate the dog's bowl
179 Make it with Sophia Loren
180 Live it up and die in bed
181 Fold up
182 Throw in your hand
183 Heave ho
184 Float away to a star
185 Be a bit nifty
186 Have a bit of an argey-bargey
187 Whistle while you wait
188 Cough up
189 Pop up
190 Spring to life
191 Fall by the wayside
192 Subjugate yourself to wisdom
193 Cut down a tree
194 Call out names of everyone you can see
195 Dig the viola playing of Felix Paparaldi
196 Be very mean
197 Bury me beneath the old oak tree
198 Tread on a rake
199 Have a fit
200 Do something tasteful
201 Pretend you are somewhere else
202 Gore Vidal
203 Don't anticipate anything
204 Be left holding the baby
205 Unfold newspaper
206 Stamp foot
207 Tear paper
208 Tear Polythene
209 Put up umbrella
210 Blow out candle
211 Scratch back
212 Build sand castles
213 Spin a circle
214 Chant
215 Rub your knuckles on shiny surface
216 Divide a loaf by a knife
217 Take an option
218 Fly
219 Multiply
220 Memorise a magic square
221 Eat
222 Drink
223 Do up your shoe laces
224 Co-operate with someone
225 Write your memoirs
226 Get the boys down

227 Something with string
228 Rip down washing line
229 Lick the bowl
230 Make a debut
231 Get into it up to your ears
232 Strap a cake round your head and drive off
233 Strap a lamb chop round your head and drive off
234 Frustrate an urge
235 Succumb to a temptation
236 Avoid an antithesis
237 Seek a recurrence
238 Blow nose
239 Do a star turn
240 Do the ton
241 Come off
242 Paint your monster
243 Cultivate a speech impediment
244 Don't take anything for granted
245 Vomit
246 Spray a policeman's helmet gold
247 Bang with a hammer
248 Mend a motorbike
249 Be late for work
250 Bathe
251 Something with whitewash
252 Thread needle
253 Daydream
254 Clasp hand to forehead and stagger
255 Grovel
256 Ask someone for help
257 Leap into the shadows
258 Get into position
259 Hog what is yours
260 Gesticulate wildly
261 Clean teeth
262 Wash someone's feet
263 Count your blessings
264 Hesitate
265 Start a fire
266 Put it out
267 Put it in
268 Extend — rhinocerous; funny things, awful day in May
269 Put out the light and then put out the light
270 Something ridiculous with fire lighters
271 Make a ring like a very stupid person
272 Initiate a rite
273 Camp one
274 Be evasive

275 Hide your errors
276 Involve a disinterested party
277 Hack your way through a forest
278 Something nasty with cork screw
279 Exaggerate every move
280 Circumnavigate
281 Adjust your colour TV
282 282 similar things
283 Rub shoulders with the stars
284 Buy scrapbook and stick pictures in it
285 Groan
286 Annoy
287 Tease
288 Expostulate
289 Procrastinate
290 Clear up after yourself
291 Belch
292 Pretend easter eggs
293 Associate yourself with a smelly person
294 Emasculate
295 Cut out shape in felt, select diamonte studs, sequins, beads, lurex thread, metal buttons, gold and silver foil. Stick or sew these onto material
296 Close your eyes and think of England
297 Measure distance between you and nearest person
298 Make notes about cornices
299 Read out headlines
300 Implicate your neighbour
301 Animal sounds
302 Dig up hogweed in the dusk
303 Play tunes on glasses
304 Excuse yourself with vain promises
305 Whistle
306 Polish shoes
307 Make paper sculpture
308 Turn backward somersault in the air
309 Balance eel on end of nose
310 Make a detailed analysis of all deaths and draw your own conclusions
311 Include cigarette ends in an inventory of the heath
312 Overwhelm somebody
313 Make lamps out of old wine bottles
314 Sing a lullaby
315 Get it together
316 Throw custard pie
317 Stone the crows
318 Be in Carolina in the morning
319 Look for a silver lining

320 Hop on a bus
321 Look after the pennies
322 Watch a painting depreciate in value
323 Take a long time to realise something
324 Trace a picture
325 Frighten a little girl
326 Listen
327 Bend and stretch
328 Gimme that old time perversion
329 Let the grass grow under your feet
330 Dream a little dream with me
331 Abide with me
332 Play Beethoven
333 Pay attention to the person furthest away from you
334 Watch out for falling debris
335 Embark on a gigantic enterprise
336 Make the situation worse
337 Give a sucker an even break
338 Take sides
339 Chart your position in relation to the meridian
340 Become emaciated
341 Give up being an artist
342 Define your terms
343 Listen to Vivaldi in ironmongers shop
344 Fly kites
345 Fade away
346 Go as far as possible in one direction
347 Rearrange the decor
348 Make your breathing audible (but not forced)
349 Run around the block
350 Listen out for a fire engine
351 Influence someone
352 Communicate non-verbally
353 Something with giant sized imitation box of chocolates
354 Burn down a building
355 Scratch left ear
356 Stroke a cat
357 Cover the streets with banana peel (slippery town)
358 Buy product you've seen advertised on TV
359 Cut down tree
360 With heavy disguise ...
361 Take off some clothes
362 Knock down wall
363 Don't eat, don't drink, don't smoke, don't move, scarcely breathe
364 Hop up and down on a sporron

365 Open all the windows and doors
366 Squeak
367 Shudder
368 Sigh deeply
369 Attract someone's attention
370 Go, bash a sparrow
371 Jump up, throw a wobbly
372 Nick a quid
373 Sit on a pumpkin
374 Enjoy the sun
375 Dig in
376 Carve your initials on a nice piece of furniture
377 Eat fish paste
378 Stop sniffling
379 Wear goggles
380 Warm your feet
381 Dig up a worm
382 Clear out the;grate
383 Break the land speed record
384 384
385 Minus one
386 Start all over again
387 Jump up in the air, and shriek at the sight of a spider
388 Get in the back way
389 Be obscene
390 Educate yourself
391 Make it known that you can't spell
392 Feel queer
393 Puke
394 Recover
395 Never again
396 Tell a yarn
397 Slip into the North Sea
398 Fish a big 'un
399 Stop
400 Electrocute yourself (not seriously)
401 Burn yourself (seriously)
402 Poke your tongue out at a first-aid man
403 Call for help
404 Fall over backwards
405 Resent the fact that you are on television
406 Rejoice that you can't get ITV
407 Put your foot through the screen
408 Lie in mud
409 Stare a worm in the face
410 A hangover from the Beethoven Bi-centenary
411 Pot-boilers
412 Enjoy it for its own sake

413 Capture the scent of heather
414 Charlie is me darling
415 Don't worry
416 A linguistic tour-de-force
417 A higher artistic plain
418 Get in a rut
419 Feel a right tit
420 Creep up from behind
421 Put your gloves on
422 Come and go
423 A gentle and imaginative soloist
424 Seems mistakenly cast
425 Bump off your old aunt
426 Tread on a sausage-dog
427 Get it back to front
428 Double your money
429 Ten Blake songs
430 Feel admirable
431 Balance a plank on your head
432 Clutter yourself up with spuds
433 Over-do it
434 Walk over the ceiling (no, really)
435 Clean out the latrine
436 Tear off the toilet paper
437 Make a complete recording
438 Stick it out
439 Walk out of the door, trip-up and bash your head
440 Rub your hand
441 Get somewhat enlarged
442 Drink 42 of something
443 A big boot in the guts
444 Give some blood
445 Fall off a bridge in a wood
446 Suffer like nobodies business
447 Crash
448 Blow a fucking great hole in a run-way at Heathrow
449 Destroy Tesco's in any small town
450 Discuss until you come to blows
451 Sink into oblivion
452 Run away from a load of yobs
453 Wiggle like a Dude
454 Show-off
455 Scrupulously balance yourself
456 Give up
457 Don't follow on
458 Hit a six
459 Run like billio and catch your finger in the

fence
460 Wrestle with your conscience
461 And now on to opera
462 Steal the limelight
463 In the days of Melba and Tetrasini
464 Steal a bakers dozen
465 Sing Rossini sloppily
466 Allow a luscious curve to whip around your Bristols
467 Pack em in
468 Dig for all your worth
469 Regal and stately and the LSO
470 An unbreakable web of sound
471
472 Let your hair down
473 Born at lunchtime on a Sunday
474 Get a bit lovey-dovey
475 Inquire into Fred Boot's magic
476 Feel reluctant to go on stage as Stuart Burrows
477 Get down
478 Choose a delightful cabbage and tear it out of the ground
479 Wait in the labour exchange
480 Noble duetting
481 A little laugh
482 Shirk
483 Hop
484 Link
485 Finger a pile of papers
486 Bolt's Brahms by the LSO
487 An extra lift of excitement
488 Go wenching
489 On a razors edge
490 Lust on a pretty girl or handsome bloke
491 Wish you were here
492 A strong and understanding appreciation
493 An ignorant garage owner
494 Siphon jam-tarts into a bucket
495 Roll a Christmas cake along the M1
496 Get caught on barb-wire
497 Listen to the Archers for one week
498 Spit on a jerk
499 Grasp a pussy-willow
500 Keep it up
501 Correspond
502 Scratch about
503 Slide around
504 Take something in for servicing
505 Mend a light bulb

506 Address yourself to Roast beef
507 Wicked Wednesday
508 Soliloquise
509 Hope for the best
510 Hear a lecture
511 Get bitten
512 Write your diary
513 Phone your analyst
514 Scrutinize a watch that doesn't work
515 Arrange a meeting
516 Cancel a concert
517 Coat your tongue with 100s & 1000s
518 Have nothing to say to your brother
519 Pour
520 Read a
521 Read b
522 Write a trio
523 Hunt plants by the riverside
524 Feel drained at low tide
525 Tear your hair out in frustration (really)
526 Think someone else's thoughts
527 Formulate exercises relating to interpenetration
528 Wade through sewage
529 Roll yourself clean in long grass
530 Rattle a rabbit
531 Attack the inaccessability of other peoples' ways of life
532 Sing for your supper
533 Walk around wearing a second skin
534 Think of your ancestors and feel ashamed
535 A great noise – a *very expensive* noise
536 Take apart a lock and see how it works
537 Eat love-letters (subsist on a diet of love-letters)
538 Egg-cup, ash-tray, inkwell (Trio 1)
539 YH 629685C
540 Plunge from a negligible height
541 Eclipse the Sun
542 Stamp on your foot
543 Eat your chin
544 Laugh like a drain
545 Button your lip
546 Cross your bridges before you come to them
547 Damn your eyes
548 Drop a curtsy
549 Drop a line
550 Drop a clanger
551 Drop your h's
552 Drop a perpendicular
553 Drop in

554 Drop out
555 Put your foot in it
556 Be put out
557 Lose track of time
558 Lose face
559 Put your left leg in
560 Put your left leg out
561 In, out, in, out, shake it all about
562 Do as you would be done by
563 Be done by as you did
564 Eternalise
565 Dangle
566 Jangle
567 Wrangle
568 Tangle
569 Mangle
570 Spangle
571 Blow the gaff
572 Fall about laughing
573 Jump up and bang your head on the ceiling
574 Explode a hypothesis
575 Expound a theory
576 Make your blood boil
577 Imitate Che Guevara as a small badger
578 Change guard at Buckingham Palace
579 "You'll never go to heaven if you break my heart"
580 Who says?
581 Be Rife
582 Incline your head till it touches the ground
583 Break the large glass
584 Arrest a Policeman
585 Singing Balls to the Baker, arse against the wall
586 Climb every mountain
587 "Fuck my old Boots"
588 The two fingered sign of distaste in conjunction with something sweet and sugary, painted yellow, lusciously curving into the distance, taking her pants off, reaping the whirlwind and singing a twelve bar blues on the back seat of a tandem tricycle
589 Come to a pretty pass
590 Come to a pretty lass
591 Sweat like a pig
592 Burn the boats
593 Shiver me timbers
594 Splice the mainbrace
595 Drink like a fish
596 Swear like a trooper

597 Arsenic and old lace
598 Be written off
599 Wreck yourself with a rusty mattock, the handle of which is exquisitely carved, inlaid with ivory and set with precious stones
600 Translate the Hsin-Hsin Ming into Medieval Russian
601 Write a précis of the Bible in words of not more than one syllable
602 Play the whale
603 Fish for compliments
604 Fish for fivers
605 Fish for the notes
606 Land a gigantic catch
607 Make a false entry and still hold back
608 Giver her/him satisfaction
609 Take it easy, but take it
610 Demonstrate the sound of one hand
611 Fall among thieves
612 Fall into arrears
613 Fall into disfavour
614 Fall into disgrace
615 Fall into a vat of boiling dung (or oil)
616 A little of what you fancy
617 Throw the world over, the white cliffs of Dover
618 Turn a Chinese Revolution
619 Make a Venetian blind
620 Make a Maltese Cross
621 Fly in the face of danger
622 Put on a brave face
623 Fly on the face of her Majesty the Queen
624 Pollute a bowl of custard
625 Dispute a Death sentence
626 Rumble the Popish plot
627 Give a detailed exposition as to the reasons for Titus not getting his oats
628 Make peace
629 Make war
630 Make love
631 Make friends
632 Make amends
633 Rake up your past
634 Dig up your potatoes, trample on your vines
635 "Gimme that thing"
636 A cat's lick and a promise
637 Grow younger from today
638 Make-up
639 Decree a repetition, of the Spanish Inquisition

640 Keep your head in the presence of a tiger
641 Make yourself a jacket out of National Velvet
642 Invest in squirrels
643 Go on for longer than you intended
644 Go on for longer than you expected
645 Go on for ever
646 Throw fifty fits, make allowance for the proximity of spectators
647 Laugh fit to bust
648 Laugh till you cry
649 Laugh till you break your jaw
650 Lie on the bottom of a swimming pool and breathe in deeply
651 Repeat 650 wearing an atomic powered kilt and seven league boots
652 Up an' give 'em a bla' a bla'
Wi' a hundred pipers an' a' an' a'
653 Moonlight and roses and parsons' noses
654 Every lassie loves his laddie, coming through the rye (misquote)
655 "Someday my prince will come", Something with a pitch fork
656 Home, home on the range, where the people are acting so strange
657 Show them who's boss, then resign your position
658 Run the gauntlet
659 Be the object of a fugue subject
660 Give a tonal answer to a rhetorically insulting question
661 Be "cut to the quick"
662 Be quick to the cut
663 Do the dirty on somebody
664 Breeze it, bugg it, easy does it
665 Lose your cool
666 Lose your virginity
667 Lose your self respect
668 Be caught with your trousers at the cleaners
669 Beat your wife with a damp squid
670 Pick your nose with a mechanical shovel
671 Feel glad all over. (How did "Glad" enjoy it?)
672 Be pipped at the post or (conversely) give somebody the pip
673 Get the pip or (conversely) give somebody the pip
674 Set the pips on a well known politician
675 Loop the loop
676 Squander your ill-gotten gains

677 Beg for mercy
678 Take yourself down a peg
679 Question your bank statement
680 Never say die
681 Do or die
682 Die the death
683 Become a dyed in the wool dogmatic
684 Unfrock a clergyman
685 Bat an eyelid
686 Turn the other cheek
687 Whippoorwill
688 Pursue a will o' the wisp
689 Make a bloomer
690 Rut
691 Split your difference
692 Turn up trumps
693 Give a light show to a heavy audience
694 Make a face at a tree
695 Give away the game
696 Let the cat out of the bag
697 Hunt the thimble
698 Make out a case for a logical bassoon
699 Syndicate every boat you row
700 Indicate every thing you see
701 Celebrate every thing you are
702 Dig a pony
703 Photograph the back of your head
704 Make a sculpture of the wind
705 Paint your anus
706 Fight the good fight, each and every night. Cor strike a light, with all thy might
707 "Know the male but keep to the role of the female"
708 Thank Lao Tzu for "707"
709 Thank D C Lau for translating "708" from the original Chinese
710 Conquer the ineluctable
711 Know the wisdom of refraining from action
712 Polish off a three-course breakfast at 3 o'clock in the afternoon
713 Leap before you look
714 Leak before you loop
715 Loop before you leak
716 Clean your teeth with a universal spanner
717 Knock your friends down with a feather
718 Swing a cat
719 Swing a Blue Whale

720 Up, up and away
721 Help an old lady across the road against her will
722 Drink a yard of ale
723 Drink a yard of whisky
724 Hold a special service in the memory of anyone attempting "723"
725 Speak now or forever hold your peace
726 Commit perjury
727 Walk around London in Indian file
728 Have a picnic on Hammersmith Bridge
729 Say the unrepeatable
730 Ball the Jack
731 Touch the moon
732 Be a bit of a bastard (which bit is up to you(?))
733 Play with your friends
734 Play with your self
735 Cycle up the steps of the Eiffel Tower, then cycle down again
736 Walk backwards for a hundred yards then run backwards for a hundred yards
737 Collapse as if exhausted, dissimulation will not be permitted
738 Brush up your Shakespeare
739 Do something for Pete's sake
740 Part your hair from ear to ear
741 Grow a moustach in the small of your back
742 Run amok
743 Make some Holy smoke without a celestial fire
744 Take off your clothes before a paying audience sitting in total darkness
745 Perform a five card trick and amaze your friends
746 Execute a lithograph of a pig in a poke
747 Count the number of hairs on the back of each hand, and take down the number of the difference, climb the same number of trees with a chamber-pot and a small goat strapped to your back
748 Fiddle while Rome burns
749 Given an imitation of the Vienna Secession, blindfolded and standing in a bucket of pirana fish
750 Give a Royal Command Performance of Gavin Bryar's "Serenely beaming and leaning on a fivebar gate"
751 Turn topsy-turvy
752 Don't come that one
753 Knit your brows so that they keep your eyelids warm in winter
754 Perform "175" with your head tucked underneath your arms

755 Now for something completely different
756 Open up them Pearly Gates
757 Swim the Channel underwater
758 Fall asleep during page five of John Cage's "The Music of Changes", Book III
759 Fall awake during Group 139 of Stockhausen's "Gruppen"
760 Whistle to your hearts content
761 Take some coal to Newcastle
762 Kiss the Blarney Stone
763 Wipe your slate clean
764 Rape a canary
765 Construct a short way to Tipperary
766 Put off procrastinating till tomorrow
767 Regurgitate an eel pie
768 Put out a candle and apologise to it for so doing
769 Flush the lavatory with one almighty stroke of the pen
770 Drown one of larger types of rodent with the sweat of your brow
771 Shave the cat with a few sharp words
772 Confucian confusion
773 Be redundant
774 Learn to recognise St Peter's Square, and so is the Pope
775 Confine yourself to a wheel chair for the day and make a round tour of the bottoms of crowded staircases. (Be a nuisance!)
776 Remember something you had long since forgotten
777 Board and leave a tube train inbetween stations
778 Broadcast to the Nation
779 Paint your face in the dress tartan of the clan Macleod
780 Satire:— send up a balloon
781 Forfeit your right to live
782 Hold your own with one hand and someone else's with the other
783 Argue till you are black in the face (a coloured issue?)
784 Talk to a brick wall
785 Ask a ticket machine for your money back
786 Begin hesitantly, continue nervously, expound at great length and end in a blaze of glory
787 Finger pie
788 Suddenly become lop-sided
789 Grow on trees
790 Use your loaf
791 "You're no fun anymore" — illustrate with

special reference to Egyptian masochism in the thirteenth century B C

792 "Let's all sing like the birdies sing, twit, twit, twit, twit-twoo"
793 "Be still and know"
794 Call the whole thing off
795 Leave your visiting card at a house of ill-repute
796 Be dishonest when writing your memoirs
797 Visit a dying race
798 Run in a dying race
799 Express the desire for a glass of half and half
800 Stain your character
801 Remove a blot from your escutcheon
802 Leap at an opportunity
803 Lift a cat from some hot bricks
804 Strangers in the night
805 Feel the urge to be pessimistic
806 Back a loser
807 Back a winner
808 Back a portrait of "La Gioconda" with an heretically obscene sonnet
809 Be pleased as punch
810 Be rotten to the core
811 Open someone else's letters
812 Walk three abreast, backwards through a hedge
813 Visit Hampton Court Palace and be amazed
814 Flashback
815 Openly dismiss your own congruity
816 Certify your own death
817 Certify your own insanity
818 "Take me back to dear old Blighty"
819 "Take me back to dear old Blighty"
820 Propose a toast
821 Drink a toast
822 Eat some toast
823 Toast the most
824 Question your own existence
825 Question your right to live
826 Feel obliged
827 Mollify a mitigation
828 Emulate an albatross
829 Remark yours faithfully ジンカルヤ ゲルゲ
830 フンフ ルニル゠、 ゠ニ゠イ ニ イ
831 Decipher "830"
832 Fly by night
833 Tailor a coat of arms
834 Force an entry
835 Force a reply
836 Force a window

837 Force a lock
838 (Gabriel) Fauré's a jolly good fellow
839 File a complaint
840 File a lawsuit
841 Fall down a disused well
842 Draw up your plans
843 "Bless your beautiful hide"
844 Draw up a chair
845 Cut it fine
846 Cut a fine figure
847 Dash out
848 Dash in
849 Deviate wondrously, and in bright colours and blinding flashes
850 Foam at the mouth
851 Drink a glass of water standing on your head
852 Give a damn
853 Open an old wound
854 Seal a pledge
855 Redeem a pledge
856 Pledge your support
857 Thank you for your support, I will wear it always
858 Fall into misuse
859 Issue a statement
860 Tamper with the facts
861 Sing obscene words to the tune of Annie Laurie
862 Fall over backwards
863 Even things out
864 Justify a faux pas
865 Empty the Pacific Ocean
866 Feel left out
867 Be bereft
868 Have an inkling
869 Be detached at her Majesty's Pleasure
870 Send a letter to a person of no fixed abode
871 Take a wife
872 Take a husband
873 Take five
874 Take more than you need
875 Take as many as you can carry
876 Untie the gordian knot, or not
877 Become diffuse
878 Refract
879 Reflect
880 Recumbent
881 Recalcitrant
882 Return
883 Revoke

884 Relive
885 Relieve
886 Relearn; 886a Retire
887 Retain
888 Reverberate
889 Recognise
890 Fill your glass and keep on pouring
891 Wipe the dust off your mirror, taking the mirror with it
892 Estimate your own esteem
893 Break off an engagement
894 Come in with tide and go out with the old year
895 Strike a clock for being slow
896 Catch your breath and preserve it for posterity
897 Deepen your affection
898 Deepen your understanding
899 Deepen your iniquity
900 Deepen your hatred
901 Bang like a door in a gale
902 Depress yourself
903 Repress yourself
904 Peruse
905 Covet thy neighbour's wife/husband
906 Explete at your own proclivities
907 Keck at goodness
908 Discourse raptously upon the advantage of being a vole
909 Ridicule consummately the binomial theorem
910 Adore being a stoat
911 Fall for that old trick
912 Expel all outsiders
913 Defend a fallacy
914 Feign a heart attack
915 Invent some lurid details
916 Misquote a dumb show
917 Everybody's laughing, everybody's happy
918 Overemphasise a negative aspect
919 Find a bassoonist who declined to opt for medicine
920 Brendan Behan and his funny machine
921 Not an inch of ground beneath your feet, no tile above your head
922 Fill in some bad form
923 Open a debate on violence using a crowbar and a thermic lance
924 Reveal your true identity
925 Shake hands with the wife's best friend
926 Bid your "alter ego" goodbye
927 Come across one of your ancestors while

928 Caricature your distress at "927"
digging in a vegetable patch

929 Escape from a top security set of parentheses

930 Deem something worthless

931 Clap your hands and scare the clouds away

932 Divert the rain upwards by means of induction and/or static electricity

933 Feed the one thousand and make them pay through the nose

934 Circumnavigate a magnum of Bell's Blended Scotch Whisky

935 Walk the river Thames, underwater

936 Hijack a fire engine to Cuba

937 Consist of three things

938 Find a way in a manger

939 Back the first three horses, a) of the Derby, b) of the Grand National, c) of the Miss World Contest

940 Grow a beard and moustache; then shave away:— i) the right side of the moustache and the left side of the beard, alternatively ii) the left side of the moustache and the right side of the beard. i) and ii) may be executed in any order and in any combination

941 Exasperate yourself

942 Be surprised at your own stupidity

943 Be surprised at your own cupidity

944 Be ashamed at your own duplicity

945 Take part

946 Take part without asking

947 Compromise a polecat

948 Be Frank

949 Be Rosie

950 Be yourself

951 Expect something to turn up and be dumfounded when it does

952 Complain of unjust medical treatment

953 Raise your hands and lower your feet

954 Visit the Vicar of Bray riding on a donkey

955 Cut your toenails with a pair of tonsils

956 Pluck your eyebrows imitatively

957 Widen the straight and narrow

958 Be up to much

959 Be up to no good

960 Be up and about

961 Be above suspicion

962 Be below suspicion

963 Suspend judgement from the a) Forth Road, b) Forth Railway Bridge, c) Clifton Suspension Bridge, d) Tower Bridge

964 Open a riverbank account

965 Burn your wages

966 Buy yourself a box of chocolates and eat them all up

967 Drink a yard of ale in 38 seconds

968 Change TV channels 20 times in one hour

969 Keep a stiff lower lip

970 Bite upper lip

971 Fuck for the PTO

972 Put your hair up

973 Form a housing association

974 Light a candle for St Cecelia

975 Xerox yourself

976 Play a one-armed bandit until it's empty

977 Play a one-armed bandit until you're empty

978 Burn all your works

979 Work all your burns

980 Pick up fag butts in Claridges and smoke them there

981 Blow up a storm

982 Give up all your principles

983 Come dancing

984 Talk about George Brecht

985 Gossip

986 Eat a rat sandwich

987 Sing the signature tune of Billy Bean and his Funny Machine

988 Drink a bottle of whisky a day

989 Call a whisky-drinking trapper a liar

990 Eat baked beans on toast

991 Staccato fart

992 Hire the Wigmore Hall and give a solo concert

993 Whistle in the presence of a lady

994 Kill a commie for Christ

995 Vote conservative

996 Don't get political

997 Give a little whistle

998 Scream hysterically

999 Phone the police, ambulance, or fire brigade

1000 Pick your nose and save(our) the snot

1001 'Ave a coop o' tea

Appendix

Some compositions related to Scratch Music &
Activities

 Michael Chant. Pastoral Symphony
 David Ahern. Musikit
 Roger Frampton. Things to do for Musicians
 Greg Bright. Labyrinth II (see endpapers).

MICHAEL CHANT PASTORAL SYMPHONY

Any activity whatsoever involving two or more persons is to be approached or otherwise restricted as follows:—

1) a) The above-mentioned activity is not to be one that is being performed or carried-out for the first time, or being so performed or carried-out in a medium or mode of procedure wholly other than previous media or modes of procedure in which the activity has taken place OR b) The above-mentioned activity *may* contravene the stipulations a) regarding previous performance *provided* the activity, or medium or mode of procedure of the activity, has been composed, produced or otherwise inceived wholly or in part by a person or persons deceased at the time of the performance.

2) For the purposes of complying with the stipulations here-in comprised, every person engaged in the said activity is considered as having a *role*. A *role* is defined as an activity which can be named, or which can be described in a finite number or words (Note: those descriptions consisting of a delimited number of words ordered in a cyclic or otherwise non-finite manner—vide PRAYER (9 November 1968) of the composer—may be included in the aforesaid class of descriptions/.)

A person may elect to have a *creative* role, which is to say he is appointed to see to it that the stipulations 3) are not disregarded, and he is to bear the responsibility of the deception of those persons who have not so elected into the acceptance of a role in accordance with that role assumed by the person so electing.

Any person or persons may so elect, and any person may not so elect notwithstanding that no other person has elected to have such a creative role.

3) The said activity is to be divided into three sections I—III in order of time. Then

I is a section of the activity complied with by not more than one person. This section is voluntary.

II is a section of the activity complied with by all persons engaged in that activity. At all times during this section all persons concerned with the activity, with the exception of persons affected by but not engaged in this activity, must fulfil their roles. Those persons not electing to have a creative role are exempted from being active exclusively for the whole of the section.

III is a section of the activity complied with by one and only one person. The section of the activity herewith stipulated is such which repeats an aspect or part of the activity heretofore performed or carried-out in a manner of performance not wholly the same as in the foregoing sections of the activity. This section closes the activity.

Any person may stray from any part or parts of the above three paragraphs, notwithstanding that the whole may thereby be disregarded. In this event, where the person is engaged in, in addition to being affected by, the activity, a male person must immediately speak in order to make the situation understood by all. A female person may not so speak.

January 1969

MUSIKIT

UNIT DEFINITIONS

Accompaniment: is music that allows a solo — in the event of one being played — to be appreciated as such.

Solo: is music — in the event of one being played — which can be appreciated as such.

Cadenza: music showing a high degree of dexterity and technical prowess.

Cadence: A sound which clearly indicates the end of another sound or collection of sounds.

Chord: three or more sounds played simultaneously.

Interval: 2 sounds widely separated in time or space.

Arpeggio: 3 or more related or unrelated sounds played in quick succession.

Unison: 2 or more sounds exhibiting oneness of execution or "presence."

Obligato: Necessary or unnecessary sounds.

Ossia: alternative version usually one of easier execution.

Accent: implies option of stressing something.

Echo: 2 or more identical sounds occurring soon after one another.

Refrain: music which can be heard to recur in some way throughout any one performance.

Untune: interpretation is free.

Scale: an ordered arrangement of sounds which remain basic for any one performance.

Pause: means pause.

INSTRUCTIONS: Using the unit definitions, notate accompaniments, chords etc., in a book, using any form of notation; verbal, traditional, graphic or dimensional.

Move through the material in the written order. A book counts as one part and all parts may be exchanged for any one performance.

Play *only* the solos, accompaniments and pauses from the part in your possession. All other units should be received from another player by means of the attached hand signals.

Any player can give away what is required at that moment if what is to be given away (e.g. one player has his hand up for a cadenza, another for an echo etc.) is written in his book just before or just after the accompaniment upon which he is working or about to work or has just finished (in which case he plays an addendum).

A player gives the material to the receiver by playing his accompaniment in a manner which is varied by exactly what he is giving away, e.g. if a player gives away a cadenza, echo and interval, he might have an intervallic, echoed cadenza accompaniment.

Only qualified persons should attempt to give away more than one unit at a time.

The player should try to give away just what is written or if not then try to communicate the essence of the candenza, chord etc. or give away the essence of the definition.

The receiver should watch and listen to the giver and then attempt to reproduce exactly or with variants what he takes to be the required unit.

Where 2 or more players ask for a unit at the same time, confusion may be eliminated by allotting to each player one of the following code names, which he calls out when giving away the required units: huzza, yoiks, whizz, plash, kung, whirr, buzz, ping, clang, click, swish, fizz, swoosh, scruch, yawl.

Cadences should only be played before solos, irrespective of whether the cadence is written into your part.

The difference between accompaniment and solo is only in the mode of playing. When somebody intends to play a solo, the other players should 'switch-down', so as to allow the solo to be appreciated as such.

Sounds are to be deliberate, precise and distinct. Any visual activity should only occur as a by-product of a sound-making process.

EXCERPTS — MUSIKIT: Any unit or units may be extracted and performed by themselves as excerpts from musikit. Names of realizers should be given code and real names given at the end of the program.

Construct programs based on the units in order to form quite different sound types. e.g.

INTERVAL	or	INTERVAL
INTERVAL		REFRAIN
INTERVAL		REFRAIN
INTERVAL		REFRAIN
PAUSE		REFRAIN
INTERVAL		
INTERVAL		

Musikit is as much a method of instruction and learning or a means of constructing hopefully fruitful programs as a composition.

David Ahern 18. 1. 71.

THINGS TO DO FOR MUSICIANS

WIND INSTRUMENTALIST(S)

Using a	flute	play your mouth
	saxophone	
	recorder	
	clarinet	
	bassoon	
	oboe	
	trumpet	
	trombone	
	tuba	
	cor anglais	
	others	

STRING INSTRUMENTALIST(S)

Using a	violin	play your bow
	viola	
	'cello	
	double bass	

Using a	guitar	play your fingers
	mandolin	
	harp	
	others	

KEYBOARD INSTRUMENTALIST(S)

Using a	piano	play your fingers
	harpsichord	
	organ	
	celeste	
	others	

PERCUSSIONIST(S)

Using a	drum	play your	stick(s)
	cymbal		beater(s)
	gong		mallet(s)
	xylophone		hand(s)
	marimba		brush(es)
	set of tubular bells		others
	tambourine		
	triangle		
	pair of maracas		
	others		

SINGER(S)

Let the song sing your voice

Roger Frampton 3.12.70.

Greg Bright LABYRINTH II

(NB A fotostat of the maze in the endpapers of this book may be used for performances of this piece)

Place a large 2-space paper labyrinth on the head of a large drum.

Players: One 'Tracer' and any number of 'Watchers'.

WATCHERS: These should be seated around the drum comfortably, in a similar manner to the Tracer (e.g. Tracer sits on floor; Watchers sit on floor. Tracer sits on chair; Watchers sit on chairs), with a good view of the maze. All Watchers have a glass of water from which they may drink at any time, with one exception (ie there is one glassless Watcher). All their concentration should focus on the Tracer's journey around the maze; they may close their eyes and listen to the quiet scratching from time to time.

The Watcher without a glass has the task of signaling the passage of time. He should have an ostensibly silent watch or clock and a sound producing article (e.g. gong), which should be neither quiet nor loud, and should make a sound suitable to the proceedings. He should make a single sound at each marked point in time. (e.g. one beat of a gong; one drop of a handful of coins). The time should be marked off in an arithmetical progression where the factor by which each term increases should itself be in an arithmetical progression.

Example: original factor $\equiv 2$
 secondary factor $\equiv 1$
 1st term $\equiv 3$

Then (taking one minutes 1 unit)
1st sound is made at 3 minutes after the beginning.
The 2nd sound at (3 mins + original factor, ie 2) 5 minutes after 1st sound.
3rd sound at $(5 + [2 + 1]*) = 8$ minutes after 2nd sound.
4th sound at $(8 + [3 + 1]) = 12$ minutes after 3rd sound
5th sound at $(12 + [4 + 1]) = 17$ minutes after 4th sound etc. — the sounds thus becoming less and less frequent.

(* the secondary factor)

N.B. (i) Timing should commence approximately when the Tracer draws the match. (ii) Any measure of time (e.g. 1 sec, 30 sec, 1 min, n mins) may be taken as one unit. (iii) The numerical progression may be worked out before or during the performance, or a combination of both.

The TRACER: After settling in his position, he should take a match (preferably new from an unopened box) and, using the wooden end, begin tracing his way through the labyrinth. He should barely pause to rest. His labours must continue until he reaches the end of the labyrinth. While the Watchers sit in contemplative calm, the Tracer's eyes may be watering from the strain; beads of sweat may appear on his forehead.

— NOT A WORD IS UTTERED THROUGHOUT —

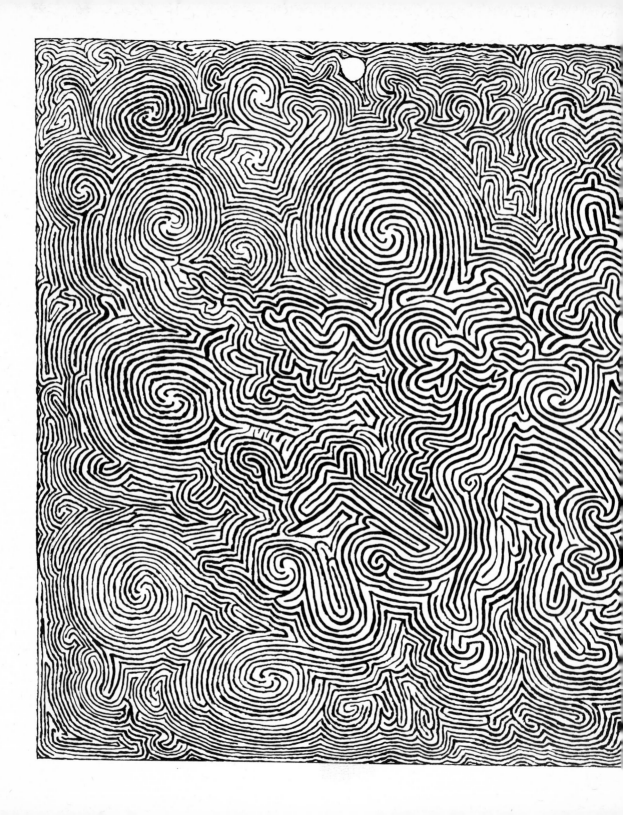